Knit Knitavian Style

Allow your knitting adventures to begin.

Thanks Arlene —
Knit with glee!
Margaret

Margaret Nock

AuthorHouse™
1663 Liberty Drive
Bloomington, IN 47403
www.authorhouse.com
Phone: 1-800-839-8640

First published by AuthorHouse 9/2/2010

ISBN: 978-1-4520-5945-7 (sc)

Library of Congress Control Number: 2010912990

Printed in the United States of America
Bloomington, Indiana

This book is printed on acid-free paper.

authorHOUSE®

Table of Contents

Foreword

Knit Knitavian Style would not have been written without the encouragement of readers' e-mails, suggestions, comments, and requests. I hope that you will enjoy the patterns, take the Joyful Knitter Oath, and allow your creativity to flow and your knitting adventure to begin.

Sincere gratitude to the following:

Dave Nock, for sharing the adventure of life and love

Molly and Max, for keeping me grounded

Michelle, for her youthful and contagious enthusiasm

Lisa, for being a good friend

Tom and Frances, whose spirit I feel every day

Lea, who selflessly taught me to knit

Author House Staff and Editorial Service

Craft Yarn Council of America

And to JMC, who always encouraged me to do more

"Fair Winds and Following Seas" (nautical blessing of unknown origin)

Book Cover:

Yarn from LollyYarn on Etsy.com http://www.etsy.com/shop/lollyarn

Photo Materials:

Joann.com, http://www.joann.com

The Pumpkin and the Cauldron Celtic Cross Journal, http://thepumpkinandthecauldron.com

Tinkrncrab on Etsy.com http://www.etsy.com/shop/tinkrncrab

Read Before You Begin

Gauge

I have included gauge information with each pattern. It's important, and helpful, to knit a swatch before starting any project. Your swatch will ensure accuracy in the final fit, especially when substituting a yarn. Regardless of the needle size indicated in the pattern, use whatever size gives you the stated gauge for the project. The yarn band gauge suggests a yarn will work to a certain number of stitches, however, your gauge will vary according to tension, needle size, yarn, and stitches used. I find it helpful to knit at least a 6" x 6" /15x15cm swatch for a project to ensure fit.

UK and US Knitting Terminology

Much of the terminology is the same, but there are a few differences you may notice in the patterns. Please refer to the Yarn Standards Guidelines section for guidance.

Materials

If you're substituting yarn for any of these patterns, please refer to the guidelines from the Craft Yarn Council of America's Standard Yarn Weight System, included in this book.

Blocking Methods

Your completed knit project may not be as smooth and even as you would like. Your tension, type of stitches used, and yarn are all factors in the outcome of your knitted piece. You can finish your knitted project by blocking it. The blocking method allows you to shape your project for a more desired look. Please refer to the Craft Yarn Council of America's Yarn Label Information chart included in this book.

Always read your care directions on the label. If you apply heat to wool with an iron, it could result in unwanted felting.

1. Dampen your knitted project and lay flat on blocking board or surface. Smooth to desired size and shape, and pin with rustproof pins. Let dry undisturbed overnight or until dry.

2. Another easy method is to lightly dampen your knitted project and lay it flat on an ironing board. Place an ironing cloth over the project and lightly place an iron on low to medium heat over the cloth. Gently press the iron on the cloth, taking care not to drag the iron over the project, until you have desired size and shape. You can also pin the project to your ironing board to keep it from slipping.

Hand-Knit Gifts

If you're knitting a gift for someone, consider including extra matching yarn for quick fixes. Care instructions found on the label of your yarn ball, skein, or hank can also be included along with a photo of the finished item. Wrap you gift project in an airtight, plastic, storage bag for safekeeping.

You will need to have basic knitting skills to complete the patterns in this book. I have included a skill rating and stitches used in each pattern, as well as resources for you to review, color photos and instructions. Some of the patterns offer a simple single crochet edging as an option. Feel free to add the knit or crochet edging of your choice.

I encourage you to relax and enjoy the process of knitting. Ask for help from your local yarn store or knitting group. Utilize online communities like Ravelry. Experiment with fiber, learn new stitches and techniques. Allow your creative spirit to soar.

Knitavia Is a State of Mind

Grab your mochas, teas, and fruit smoothies. It's time to relax on the knitting couch or lawn chair, click your needles together, and wave your hooks for the land of Knitavia.

When you're knitting the projects in this book, I'd like you to be taken to a world where everyone communicates in knit speak, lives to knit, and breathes in that new knit smell every day. You will enjoy the smell of luscious yarn, colorways, and creativity. It's a place where all your knitting dreams come true. Plush yarn, fun projects, and zero-calorie triple mochas abound in Knitavia. It's easy to adapt to the Knitavian state of mind. You will find yourself going there anytime you feel stressed, low, or in need of comfort. It will also be a place to journey when you're full of ideas, motivation, and hope. Fellow Knitavians will embrace your patterns, ideas, projects, and innovative colorways. They will offer you support for your creative flair and cheer your efforts.

Knitavian traits are easy to spot and contagious. Knitavians have a keen sensitivity to beautiful colors in nature, a love of chocolate, cozy sweaters, and zany hand-knit socks. They laugh and smile easily, enjoy new ideas, and selflessly share their knowledge with other knitters.

There is a deep desire to learn all things that involve knitting. They often schedule knitting events and revel in community, online and local.

Knitavians are compassionate to those in need and will voraciously knit items for charity. They are dedicated activists, moms to future knitters, stay-at-home dads, busy executives, all ages, large, and small. And all are involved in knitting. There is a reverence for the wild and adventurous knitters from the past, and they artfully celebrate living a full knitting life. Knitavians will encourage you to dance with gusto in vintage, sparkly disco vests and boas made with novelty yarn. You will notice the Knitavian community values all crafts, the arts, languages, and community. Humor plays a large role in Knitavian daily life.

Knitavia is a part of all of us. Click your needles, and you're there. Look for glimpses of Knitavia everywhere you go. Carry it with you through struggles and good times. Knitavia will inspire you when facing challenges and setbacks. Find peace there, and visit daily.

Knitavia is constantly evolving. You add your own awareness of knitting to the community when reading and knitting the projects in this book.

Go to Knitavia in your mind, in your dreams, and look for fellow Knitavian adventurers in your community.

Now it's time to allow your knitting adventures to begin.

Joyful Knitter Oath

> *I promise to share my knitting skills with my community, knit often in public, and learn new knitting skills every year. I will share my knitting knowledge, laugh, and feel joy every day.*

Congratulations! You are now a part of Knitavia, the knitting community, and a joyful knitter.

Handy Knitting Tools

Here are a few tools I find handy to have around. They are not all mandatory and can be accumulated as needed. As you grow with your knitting, you will discover your own favorite tools to add to your knitting accessories.

- tape measure
- stitch markers
- gauge for measuring stitches (often includes gauge to measure needle size)
- large-eye and regular-eye tapestry needles
- interchangeable needle set

- needletip covers to keep your stitches from falling off the needles
- row counter
- small sewing scissors
- pouch, totebag, or container to keep your items organized and readily available to take anywhere you go

A primary "how-to" knitting resource guide will be very helpful to you over time. Look for easy to read books with photos. I have included books that I use often in the Knitting Resource Books section and on my Web site, knit1fortheroad.com.

Knitting Is Like Sushi

In the beginning, you're not sure what to do. You might even say it's not your thing, but eventually, you try it. You get hooked, because you had the right person show you the way and help you pick out the right delicacies on the menu. The same goes for the experience of knitting. You will want help picking patterns that are the right skill level so that you don't become frustrated. Look for good descriptions and a skill-level rating of easy in your patterns when you are just beginning to knit. In many communities, local yarn or craft stores offer reasonably priced classes; some are free. There are many free online videos to help you and links on my Web site, knit1fortheroad.com, that will guide you.

If you've been knitting for a while, keep learning and studying. Try a new stitch or finishing technique to enhance your knitting and crochet skills.

Why not try spinning or dying your own fiber? There are many free felting tutorials online and knitters in your community that will help you. You will discover new skills with fellow knitters, who perhaps eat sushi and love chocolate as much as you do.

The Patterns

The patterns in this book are inspired by colors and textures in natural surroundings. I've included yarns that I enjoy working with and knit items that I use in my own life. My hope is that you will enjoy knitting the patterns over and over, and that you will add your own flair, try new finishing techniques and incorporate your enthusiasm into each project. I have a gallery on my Website, knit1fortheroad. com and welcome your pictures to share with other Knitavians.

Knit with glee!

Cover Me Amazing Snood

Wrap yourself in this scrumptious snood and enjoy the amazing way you feel.
(Easy—basic knitting skills required)

Finished Size
x44"/112cm

Materials
- 2 skeins Lion Brand Amazing, 1.75 oz (50g), 147 yds (135m),
 medium (#4), 53% wool, 47% acrylic, in Arcadia.
- 1 pair US size 9 (5.5mm) needles, or size needed to obtain gauge
- Tapestry needle
- Stitch markers

Gauge
16 stitches/18 rows = 4"/10cm
Always take time to check your gauge.

Abbreviations
k—knit
p—purl
st(s)—stitch(es)

Instructions
Cast on 32 sts
Rows 1–2: k.
Row 3–4: *k2, p2, repeat from * to end of row.
Repeat rows 1–4 for 44"/112cm.

Bind off and seam ends together. Weave yarn ends. Block if desired.

To Block
Always check the yarn's washing, drying, and ironing instructions before blocking.

Dampen your knitted project and lay flat on blocking board or surface. Smooth to desired size and shape, and pin with rustproof pins. Let dry undisturbed overnight or until dry.

Manly McMan Scarf

The Manly McMan scarf is the perfect scarf to make for the man in your life.
(Easy—basic knitting skills required)

Finished size
×72"/183cm

Materials
- 2 balls of Lion Brand Wool Ease Worsted, 3 oz (85g), 197 yds (180m), 80% acrylic, 20% wool, in #152 Oxford Grey.
- 1 pair US size 8 (5mm) needles, or size needed to obtain gauge
- Tapestry needle
- Stitch markers if needed.

Gauge
18 stitches/16 rows = 4"/10cm
Always take time to check your gauge.

Abbreviations
k—knit
p—purl
st(s)—stitch(es)
kfbf—knit into front, back, and front of stitch
P3tog—purl 3 stitches together

Tip: Slip first stitch of every knit row to help keep scarf edge firm.
Cast on 31 sts
Ribbing:
Row 1: k1, p1.
Row 2: p1, k1.
Repeat these two rows for 3"/8cm.

Pattern:
Row 1: k10, p5, k1, p5, k10.
Row 2: p10, p1, k10, p10.
Row 3: k10, p5, kfbf, p5, k10.
Row 4: p10, p3tog, p20.

Repeat pattern rows 1–4 for 66"/168cm.
Repeat ribbing rows for 3"/8cm.

Bind off in pattern (knit the knit sts, and purl the purl sts as you bind off).
Weave in ends.
Block if necessary.

To Block
Always check the yarn's washing, drying, and ironing instructions before blocking.

Dampen your knitted project and lay flat on blocking board or surface. Smooth to desired size and shape, and pin with rustproof pins. Let dry undisturbed overnight or until dry.

SoHo Saturday Scarf

This colorful scarf is relaxed, timeless, and stylish. Noro is lightweight and will make the SoHo Saturday Scarf a scarf for all seasons. Wear it to the market, lunch, or concert in the park. It's the perfect accessory and long enough to wear several ways.
(Easy—basic knitting skills required)

Finished Size
×67"/170cm

Materials
- 2 skeins Taiyo Noro, 3 1/2 oz (100g), 219 yds (200m), 40% cotton, 30% silk, 15% wool, 15% nylon, in Color #3.
- 1 pair US size 10 (6.0mm) needles, or size needed to obtain gauge
- Tapestry needle
- Stitch marker

Gauge
Not important for this project.

Abbreviations
k—knit
p—purl
yo—yarn over; wrap yarn around right needle before inserting it into next stitch

sc edging—single crochet edging (optional)
st(s)—stitch(es)

Instructions
Cast on 20 sts
Section A:
Row 1: *k1, p1, repeat from * to end of row.
Row 2: *p1, k1, repeat from * to end of row.
Repeat rows 1 and 2 for 38"/97cm.
Section B:
Rows 1–2: k.
Row 3: *k1, yo2, repeat from * to end of row.
Row 4: k, dropping yo made in previous row (this creates a hole).

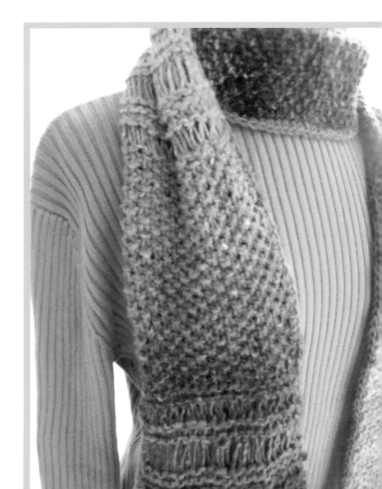

Rows 5–6: k.
Row 7: *k1, yo3, repeat from * to end of row.
Row 8: Repeat row 4.
Rows 9–10: k.
Row 11: Repeat row 3.
Row 12: Repeat row 4.
Rows 13–14: k.

Repeat section A for 6"/15cm.
Repeat section B two more times.
Repeat section A for 6"/15cm.

Bind off in pattern (knit the knits and purl the purls as you bind off).

Note: Add a crochet edging if desired. Start with 3 scs in a corner, and continue to sc around evenly: you will have 3 scs in every corner. Slipstitch into the first sc to fasten off.
Weave in ends.

Block if necessary.

To Block
Always check the yarn's washing, drying, and ironing instructions before blocking.

Dampen your knitted project and lay flat on blocking board or surface. Smooth to desired size and shape, and pin with rustproof pins. Let dry undisturbed overnight or until dry.

Scarf Option 2
Another option for knitters interested in working on speed and tension is to make a traditional garter stitch scarf. You will knit every row for 67"/170cm, or desired length. You can also add a sc edging to firm up your edges. Start with 3 scs in a corner, and continue to sc around evenly; you will have 3 scs in every corner. On the last sc, slipstitch into first sc stitch to fasten off. Weave in any loose ends and block if desired.

Lolly Luscious Scarf

Lovely Lolly yarn is soft and plush, with a hint of sparkle to make you feel beautiful. (Easy—basic knitting skills required)

Finished Size
×56"/142cm or desired length

Materials
- 2 hanks of Lolly Yarn Handspun, 10.5 oz (301g), 208 yds (191m), wool, New Day. (Note: this handspun yarn varies from bulky to thin) Visit Lollyarn.Etsy.com or contact via Lolly@LOLLYARN.COM.

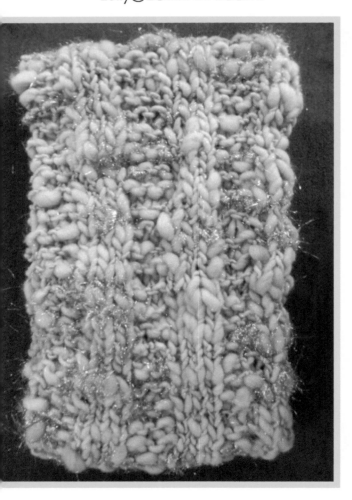

- 1 pair US size 17 (12mm) needles, or size needed to obtain gauge
- Stitch marker
- Large eye tapestry needle

Abbreviations
k—knit
p—purl
st(s)—stitch(es)

Gauge
8 stitches/8 rows = 4"/10cm
Always take time to check your gauge.

Instructions
Cast on 18 sts.
Pattern: Garter Stitch Rib pattern (multiple of 6 sts).
Row 1: *k3, p3, repeat to end of row.
Row 2: k all sts.
Repeat for 56"/142cm, or desired length.

Weave in ends.
Block if necessary.

To Block
Always check the yarn's washing, drying, and ironing instructions before blocking.

Dampen your knitted project and lay flat on blocking board or surface. Smooth to desired size and shape, and pin with rustproof pins. Let dry undisturbed overnight or until dry.

Lolly Luscious Hat

Everyone needs a warm winter hat and this one is going to be your favorite hat of the season. (Intermediate—basic knitting knowledge and skills required; you will also need to know how to use double pointed needles You may also knit in the round with circular needles.)

Finished Size
Adult Stretches to fit head circumference 22"/53cm.

Materials
- Lolly Yarn, 3.8 oz (109g), 88 yds (100m), hand-dyed, handspun wool, bulky, New Day. (Note: this handspun yarn varies from bulky to thin)
 Visit Lollyyarn.Etsy.com or contact via Lolly@LOLLYARN.COM.
- 1 pair US size 17 (12mm) double-pointed needles, or size need to obtain gauge
 Note: You may also knit in the round on a circular needle or two circular needles if you prefer. The hat pictured for this project was knit on double-pointed needles.
- Stitch markers
- Large-eye tapestry needle

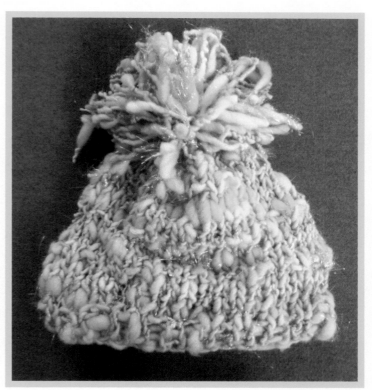

Gauge
8 stitches/8 rows = 4"/10cm
Always take time to check your gauge.

Abbreviations
k—knit
p—purl
k2tog—knit two stitches together
st(s)—stitch(es)
DPN(s)—double pointed needles

Instructions
Cast on 42 sts
Distribute your stitches evenly over your DPNs and join, being careful not to twist the stitches. Place a stitch marker to indicate beginning of round.

Ribbing:
Rounds 1–3: *k1, p1, repeat from * to end of round.
Rounds 4–5: k.
Round 6: *k1, p1, repeat from * to end of round.
Repeat rounds 1–6 for 5"/13cm.

Next round: k2tog for 2 rounds.
Cut your yarn, leaving a tail long enough to weave through the remaining stitches. Pull yarn through and tighten. Weave the yarn end through the cap and tighten any holes. Block if necessary.

Add a pompom if desired.

You can buy a pompom maker at your local yarn store or make your own by cutting out two cardboard circles the size you would like your finished pompom. Cut a dime–size hole in the center of each cardboard circle.

Next, take about 6 strands of yarn (or fewer if you are using bulky yarn) and cut them approximately 2 yards long. Hold the two cardboard circles together in your left hand. Wind the strands of yarn through the hole and around the outside of the cardboard.

The more yarn you use, the bulkier and fuller your pompom will be.

Finish your pompom by inserting your scissors very carefully between the two cardboard pieces and cutting the yarn all the way around. Separate the cardboard pieces and take a strand of yarn (approximately 12"/31cm) and wind it around the cut strands between the cardboard

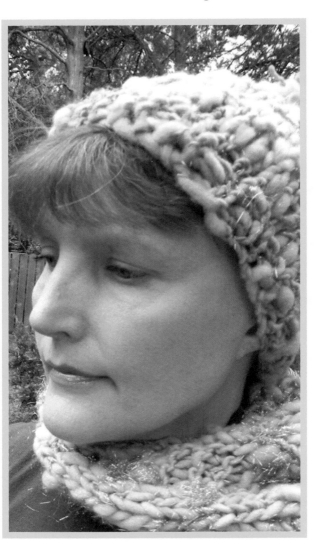

pieces two times and tie off. Trim any loose ends.

There is a wonderful tutorial on KnittingDaily. com (http://www.knittingdaily.com/glossary/pom-pom.aspx) and online videos on YouTube.com and Knitting Help.com
that demonstrate making a pompom.

To Block
Always check the yarn's washing, drying, and ironing instructions before blocking.

Dampen your knitted project and lay flat on blocking board or surface. Smooth to desired size and shape, and pin with rustproof pins. Let dry undisturbed overnight or until dry.

Savannah Chunky Scarf

I am often homesick for my hometown, Savannah. When I saw Lion Brand's Hometown USA yarn in Savannah Sage in my local yarn store, it was instant inspiration.
(Easy—basic knitting skills required)

Finished Size
×53"/135cm

Materials
- 2 skeins Lion Brand Yarn, Hometown USA, 5 oz (142g), 81 yds (74m), 100% acrylic, super bulky (#6), in Savannah Sage.
- 1 pair US size 13 (9mm) needles, or size needed to obtain gauge
- Large eye tapestry needle
- Stitch markers

Gauge
8 stitches/10 rows = 4"/10cm
Always take time to check your gauge.

Abbreviations
k—knit
p—purl
st(s)—stitch(es)

Instructions
Cast on 12 sts.
Rows 1–2: k all stitches.
Row 3: *k1, p1, k8, continue from * to last 2 sts, p1, k1.
Row 4: *k1, p1, k1, p6, continue from * to last 3 sts, k1, p1, k1.
Repeat rows 3 and 4 for 53"/135cm.
Knit next 2 rows.
Bind off.
Weave in ends.
Block if necessary.

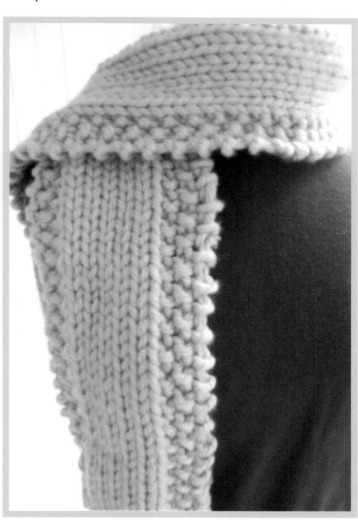

To Block
Always check the yarn's washing, drying, and ironing instructions before blocking.

Dampen your knitted project and lay flat on blocking board or surface. Smooth to desired size and shape, and pin with rustproof pins. Let dry undisturbed overnight or until dry.

Savannah Chunky Slouch Hat

Enjoy making this chunky and soft winter hat that's fun and fabulous.
(Easy—basic knitting skills required)

Finished Size
Adult Stretches to fit head circumference
22"/53cm

Materials
- 1 skein Lion Brand Yarn, Hometown USA, 5 oz (142g), 81 yds (74m), 100% acrylic, super bulky (#6), in Savannah Sage.
- 1 pair US size 13 (9mm) needles, or size needed to obtain gauge
- Large-eye tapestry needle
- Stitch markers

Gauge
9 stitches/12 rows = 4"/10cm
Always take time to check your gauge.

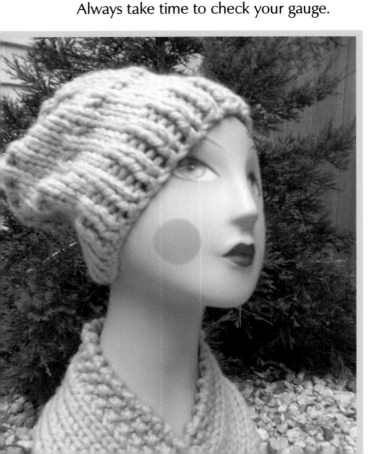

Abbreviations
k—knit
p—purl
k2tog—knit two stitches together
p2tog—purl two stitches together
st(s)—stitch(es)
rs—right side, or public side (knit side)
ws—wrong side, or nonpublic side (purl side)

Instructions
Cast on 50 sts and distribute evenly over your needles.
Ribbing:
Row 1: *k1, p1, repeat from * to end of row.
Row 2: k the knit stitches and purl the purl stitches.
Continue ribbing pattern for 2"/8cm.
k in stockinette stitch (knit 1 row, purl 1 row) for 2"/8cm.
Next,
*k1, p1, repeat from * to end of row.
p next row.
k 2" in stockinette stitch.
*k1, p1, repeat from * to end of row.
p next row.
k 1 row.
p the next row.
*k1, p1, repeat from * to end of row.

Start decreases.
*k1, k2tog, repeat to last 2 sts, k2.
*p2tog, repeat from * to last st, p1.
k2tog twice, k across to last 4 sts, and k2tog twice.

Cut the yarn, leaving a long tail (approximately 26"/66cm), and insert in tapestry needle.
Weave tapestry needle through the remaining 13 sts on needle and tighten.
Turn inside out, and seam together until the two sides are joined. Check your tension as you go, so you are not pulling yarn too tightly.

To Block

Always check the yarn's washing, drying, and ironing instructions before blocking.

Dampen and lay flat on blocking board or surface. Smooth out to desired shape and size, and pin with rustproof pins. Let dry undisturbed overnight or until dry.

Delicate Desire Fingerless Gloves

These gloves were inspired by the character Bella Swan, in *The Twilight Saga: New Moon*, by Stephenie Meyer. (Intermediate—basic knitting knowledge and skills plus some more advanced pattern stitches)

Finished Size
Adult
Stretches to fit hand circumference of
7-9"/18-23cm x 10"/25cm

Materials
- 1 skein of Lion Brand Yarn, Wool-Ease Worsted Weight Yarn, 3 oz (85g), 197 yds (181m), 80% acrylic, 20% wool, in color #118 Indigo.
- 1 pair US 8.0 (5mm) needles, or size needed to obtain gauge
- Tapestry needle
- Stitch markers
- Small stitch holder (big enough for 12 stitches)
- Measuring tape
- Row counter or other method of keeping count of your pattern rows

Gauge
20 stitches/22 rows = 4"/10cm
Always take time to check your gauge.

Abbreviations
k—knit
k2tog—knit two stitches together
p—purl
st—stitch(es)
sl—slip stitch to right-hand needle without knitting or purling
psso—pass over slipped stitch over a knitted or purled stitch
rs—right side or public side
ws—wrong side or nonpublic side
inc—increase by knitting into front and back of stitch
yo—yarnover; wrap yarn around right needle before inserting it into next stitch
RH/LH—right hand/left hand

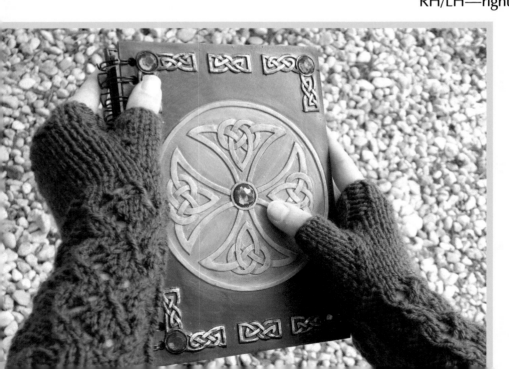

Instructions
Note L/H and R/H instructions throughout.

Cast on 33 sts
Ribbing:
K2, p2 across to end of row, k last st.
Repeat for 2"/5cm

Place stitch markers after st 11 and st 22 to help you keep your place.

You will want to use a row counter or write down rows as you go so that you can keep count, especially in the beginning.

Instructions for **Left**-Hand Glove
Row 1 (rs): k across to end of row.
Row 2: p across to end of row.
Row 3: *p2, k2tog, (k1,yo) twice, k1, sl 1, k1, psso, p2, repeat from * to end of row.
Row 4: *k2, p7, k2, repeat from * to end of row.
Row 5: *p2, k2tog, yo, k3, yo, sl 1, k1, psso, p2, repeat from * to end of row.
Row 6: Repeat row 4.
Row 7: *p2, k1, yo, sl 1, k1, psso, k1, k2tog, yo, k1, p2, repeat from * to end of row.
Row 8: Repeat row 4.
Row 9: *p2, k2, yo, sl 1, k2tog, psso, yo, k2p2, repeat from * to end of row.
Row 10 Repeat row 4.
Repeat rows 1–10 two more times.
Drop your stitch markers on next row.
Next: k across to end of row.
Next: p across to end of row.

Start LH thumb gusset.
Row 1: k 13 sts, place stitch marker, inc 1 st in each of the next 2 sts. Place the second marker. Knit to the end of the row.
Row 2: p to end of row.
Row 3: k across to first stitch marker, inc 1 st in first and last st between markers, k to end of the row.
Repeat rows 2 and 3 until you have 12 sts between your stitch markers End on RS.
Next: p 18 and remove stitch marker, slip the next 12 sts onto your stitch holder and continue to p across to the end of the row.

This is a good time to count your sts. You should have 33 sts total. If you have 32, add one stitch at the beginning of the next row to continue.

Next: inc 1 st here k across to end of row.
Next: p across to end of row.

Ribbing:
k2, p2, continue to last st, k1.
Repeat for 1"/2.5cm.
Bind off in pattern and leave yarn tail long enough to seam your glove, approximately 22"/56cm.

Finish LH thumb gusset.
Attach yarn to purl side and purl the 12 sts, turn and k12 sts. Cast off on p row, and leave a tail of yarn long enough to weave through and around thumb gusset to smooth any gaps you may have.

Seam your glove. I prefer to seam on the WS. Weave in all ends. Block if desired.

Instructions for *Right*-Hand Glove

Follow pattern for LH glove pattern from cast on to thumb gusset instructions.

Next you're going to k20 sts, place a stitch marker, inc 1 st in each of the next 2 sts. Place the second marker.

Row 2: p to end of row.

Row 3: k across to first stitch marker, inc 1 st in first and last st between markers, and k to end of the row.

Repeat rows 2 and 3 until you have 12 sts between your stitch markers. End on RS.

Next: p 20 and remove stitch marker, slip the next 12 sts onto your stitch holder, and continue to p across to the end of the row.

This is a good time to count your sts. You should have 33. If you have 32, you will need to add a stitch at the beginning of the next row to continue.

Next: inc 1 st here k across to end of row.

Next: p across to end of row.

Ribbing:

k2, p2, continue to last st, k1.

Repeat for 1"/2.5cm.

Bind off in pattern, and leave a yarn tail long enough to seam your glove, approximately 22"/56cm.

Finish RH thumb gusset.

Attach yarn to purl side and purl the 12 sts, turn and k12 sts. Cast off on P row, and leave a tail of yarn long enough to weave through and around thumb gusset to smooth any gaps you may have.

Seam your glove. I prefer to seam on the WS. Weave in all ends and block if desired.

To Block

Always check the yarn's washing, drying, and ironing instructions before blocking.

Dampen your knitted project and lay flat on blocking board or surface. Smooth to desired size and shape, and pin with rustproof pins. Let dry undisturbed overnight or until dry.

Delicate Desire Scarf

This delightful scarf was inspired by Bella's hooded jacket, designed by BB Dakota. (Intermediate—basic knitting knowledge and skills plus some more advanced pattern stitches)

Finished Size
x35"/89cm

Materials
- 2 skeins of Lion Brand Yarn, Wool-Ease Worsted Weight Yarn, 3 oz, 85gms, 197 yds, 80% acrylic, 20% wool, color #118 Indigo or your choice of color.
- 1 pair US size 8.0 (5mm) needles
- Tapestry needle
- Stitch markers
- Measuring tape
- Row counter

Gauge
16 stitches/28 rows = 4"/10cm
Always take time to check your gauge.

Abbreviations
k—knit
k2tog—knit two stitches together
p—purl
st—stitch(es)
sl—slip stitch to right-hand needle without knitting or purling
psso—pass over slipped stitch over a knitted or purled stitch
rs—right side or public side
ws—wrong side or nonpublic side
inc—increase by knitting into front and back of stitch
yo—yarnover; wrap yarn around right needle before inserting it into next stitch

Instructions
Cast on 33 sts
Ribbing:
k2, p2 across to end of row, k last st.
Repeat for 1"/2.5cm.
Next, k every row for 1"/2.5cm.

Row 1: k across to end of row.
Row 2: p across to end of row.
Row 3: (rs) *p2, k2tog, (k1,yo) twice, k1, sl 1, k1, psso, p2, repeat from * to end of row.
Row 4: *k2, p7, k2, repeat from * to end of row.
Row 5: *p2, k2tog, yo, k3, yo, sl 1, k1, psso, p2, repeat from * to end of row.
Row 6: Repeat Row 4.

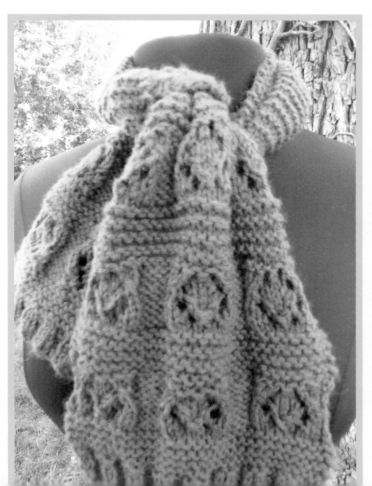

Row 7: *p2, k1, yo, sl 1, k1, psso, k1, k2tog, yo, k1, p2, repeat from * to end of row.
Row 8: Repeat Row 4.
Row 9: *p2, k2, yo, sl 1, k2tog, psso, yo, k2p2, repeat from * to end of row.
Row 10 Repeat Row 4.
Repeat Rows 1-10 two more times.

Drop your stitch markers on next row.

Next, k across to end of row.
Next, p across to end of row.
Next: k every row for 19"/48cm.
Repeat rows 1-10 three times.
Repeat ribbing for 1"/2.5cm and bind off.

Note: Your scarf edge will be scalloped where you k Rows 1-10. I really liked this look, however, you can block if desired.

To Block

Always check the yarn's washing, drying, and ironing instructions before blocking.

Dampen your knitted project and lay flat on blocking board or surface. Smooth to desired size and shape, and pin with rustproof pins. Let dry undisturbed overnight or until dry.

Do the Knitting Police Patrol Your Area?

I think not. Contrary to popular belief, the knitting police do not exist in our parks, soccer games, or at any other outdoor place we choose to knit. They are merely a knitting urban legend. Brave statement, I know, considering the knitters out there who are timid and wary of getting caught knitting in public.

As an art student, for many years, I had the audacity to sketch in a tiny notebook while in museums. I got used to every push, shove, hot breath down my neck, comments in various languages, and yes, the evil eye from time to time, mostly from museum guards. The idea of knitting in public was a piece of cake after my previous creative adventures.

Children are very curious about the outrageous public display of creativity. Some parents will say, "Come away from there!" But the children boldly reject their parents and have to be dragged away. After all, children definitely know what's cool and aren't afraid of being creative. I can understand the parents' mistrust. The children's eyes get round as saucers and the parents helplessly stand by and watch as their children are sucked into the knitting vortex. It's quite a spectacle and a bit scary for the novice parent.

Other people come up to talk about their knitting experiences and will offer ideas. Some will shyly come over and ask you questions. Fellow knitters will applaud you for bringing your knitting along and swear to bring their projects next time.

You will learn so much about human nature by being the designated knitter in your community, and it will be another knitting adventure for you to enjoy and add to your list of incredible knitting feats.

Spring Fling Wristlets

These lightweight wrist warmers will keep you warm during those in-between days right before and during the spring season.

(Intermediate—basic knitting knowledge and skills required; you will need to know how to knit on double pointed needles)

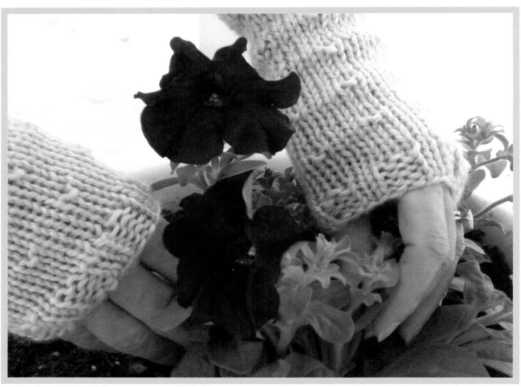

Finished Size

Adult small/medium. Stretches to 8"circumference/20 cm circumference. Measure width of hand and add stitches in multiples of 2 to make larger.

Materials

- 1 skein Caron Simply Soft, 3 oz (85g), 157 yds(143 m),100% acrylic, #4 medium/ worsted, in Orchid.
- 1 pair US size 8 (5 mm) double pointed needles, or size needed to obtain gauge
- Tapestry needle
- Stitch marker

Gauge

8 stitches/22 rows = 4"/10cm
Always take time to check your gauge.

Abbreviations

k—knit
p—purl
st(s)—stitch(es)
DPN(s)—double pointed needles

Instructions

(Make 2.)

Cast on 52 sts and distribute them evenly on your needles. Join to knit in the round without twisting yarn, and place a marker.

Ribbing:

Rounds 1–6: k2, p2.

Pattern:

Rounds 7–12: k all sts.

Round 13: *k3, p1, repeat from * to end of round.

Rounds 14–18: k all sts.

Repeat rounds 13–18: 3 more times (6"/15cm).

Repeat ribbing for 4 rounds.

Bind off in pattern (knit the knits and purl the purls).

Weave in ends.

To Block

Always check the yarn's washing, drying, and ironing instructions before blocking.

Dampen your knitted project and lay flat on blocking board or surface. Smooth to desired size and shape, and pin with rustproof pins. Let dry undisturbed overnight or until dry.

Emily's Ear Warmers

Keep your ears warm and your hair in place with this functional, yet soft, and plush headband. (Easy—Basic knitting skills required)

Finished Size
One size fits most.
Stretches to head circumference 25"/64cm

Materials
- 1 skein Lion Brand Wool Ease Thick & Quick, 6 oz (170g), 108 yds (98m), super bulky: bulky, roving yarn, weight category #6, 82% acrylic, 10% wool, 8% rayon, in 099 Fisherman.
- 1 skein of the above in 123 Oatmeal (optional for sc edging)
- 1 pair US size 13 (9mm) needles, or size needed to obtain gauge
- US N (9mm) crochet hook (optional for sc edging)
- Large-eye tapestry needle

Gauge
8 stitches/11 rows = 4"/10cm
Always take time to check your gauge.

Abbreviations
k—knit
p—purl
st(s)—stitch(es)

Instructions

Cast on 12 sts with Fisherman.
Row 1: k1, p1, k1, k6, k1, p1, k1.
Row 2: k1, p1, k1, p6, k1, p1, k1.
Repeat rows 1 and 2 for 3"/8cm.
K next 6 rows.
Repeat above pattern sequence for 18"/46cm, ending with 5 k rows.
Bind off in pattern and seam together.

Optional Finish
Add a crochet edging with 123 Oatmeal. Start with 3 scs in a corner, and continue to sc around evenly: you will have 3 scs in every corner. Slipstitch into the first sc to fasten off.
Weave in ends.

To Block

Always check the yarn's washing, drying, and ironing instructions before blocking.

Dampen your knitted project and lay flat on blocking board or surface. Smooth to desired size and shape, and pin with rustproof pins. Let dry undisturbed overnight or until dry.

Nicole's Neck Warmer

You will love knitting and wearing this simple and elegant neck warmer. Your friends are going to want one too.
(Easy—basic knitting skills needed)

Finished Size
Adult medium—stretches to fit over your head.
6" x 18"/15 x 46cm

Materials
- 1 skein Lion Brand Wool Ease Thick & Quick, 6 oz (170g), 106 yds (97 m), super bulky: bulky, roving yarn, weight category #6, 86% acrylic, 10% wool, 4% rayon, in Hazelnut.
- 1 pair US size 13 (9mm) needles, or size needed to obtain gauge
- Tapestry needle

Gauge
9 stitches/12 rows = 4"/10cm
Always take time to check your gauge.

Abbreviations
k—knit
p—purl
st(s)—stitch(es)

Instructions
Cast on 13 sts.
Pattern:
Rows 1–6: *k2, p2, repeat from * to last stitch, k1.
Rows 7–12: *p2, k2, repeat from * to last stitch, p1.

Repeat this pattern for 19"/48cm (or desired length) and end with rows 1-6.
Bind off in pattern (knit the knit sts and purl the purl sts as you bind off).
Seam side (nonpublic side) with remaining yarn.
Weave in ends. Block if necessary.

To Block
Always check the yarn's washing, drying, and ironing instructions before blocking.

Dampen your knitted project and lay flat on blocking board or surface. Smooth to desired size and shape, and pin with rustproof pins. Let dry undisturbed overnight or until dry.

Paulette's Pilates Ankle Warmers

Keep those delicate ankles warm and stylish with these cute Pilates ankle warmers. (Intermediate—basic knitting skills required; you will need to know how to use double pointed needles)

Finished Size
Adult - One size fits most.
Stretches to10"/25 circumference x 7"/18cm

Materials
- 1 ball Knit Picks Stroll, 1.76 oz (50g), 231 yds (211.23m), 75% superwash merino wool, 25% nylon, fingering weight, in Mermaid.
- Scrap sock yarn of similar weight for edging and straps
- 1 pair US size 2 double pointed needles (3mm), or size needed to obtain gauge
- Crochet hook size D or E (optional for edging)
- Tapestry needle
- Stitch marker

Gauge
28 stitches /34 rows = 4"/10cm
Always take time to check your gauge.

Abbreviations
k—knit
p—purl
st(s)—stitch(es)
DPNs—double pointed needles
sc—single crochet

Instructions
Make 2.
Cast on 63 sts.
Distribute sts evenly on needles, and join without twisting.
Ribbing:
*k2, p1, repeat from * for 1"/2.5cm.
knit every round for 5"/13cm.
*k2, p1, repeat from * for 1"/2.5cm.
Bind off in pattern (knit the knits and purl the purls as you bind off).
Weave in ends.

Optional Finish
Use your scrap sock yarn to create a sc edging.
Straps (make 2).
Use Mermaid or scrap yarn and cast on 3 or 4 sts, and knit back and forth in stockinette stitch (k 1 row, p 1 row) for 6–6 1/2"/15cm or length desired. Attach ends evenly to each side, on the wrong side. The straps will have some stretch, and measuring is always advised.

To Block
Always check the yarn's washing, drying, and ironing instructions before blocking.

Dampen your knitted project and lay flat on blocking board or surface. Smooth to desired size and shape, and pin with rustproof pins. Let dry undisturbed overnight or until dry.

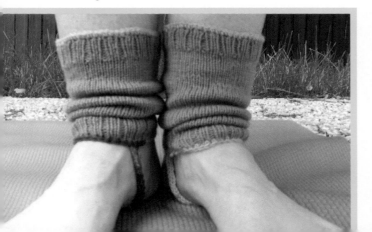

What If Your Knitting had Feelings?

Did you ever wonder, if your knitting projects had feelings, what they would be thinking about you and where you take them?

Consider taking your yarn outside for some fresh air. Go poolside. Opt for cotton fibers and alternative choices like plastic, hemp, or whatever you find fun working with. Jelly Yarn, from JellyYarn.com, comes in fun colors and is perfect for summer projects. Plastic bags can be cut in strips and knitted. Hemp and soy fibers are earthy and come in several colors.

Embellish with a few beads. Use new colors, textures, and materials in your knitting.

Wash me, wash me! Too much urban dwelling can take its toll on your projects. Gently wash, block, and share your new knitted projects with pride.

Your knitting projects always enjoy a photo op. It's their time to shine on your online project page or in a project book. It's the perfect way to keep track of your progress as a knitting adventurer extraordinaire.

Stop fretting over the brainteaser patterns that stress you. The tugging hurts, and your frustration creates bad vibrations. You're dealing with natural fibers here, folks. Take a break from your project and return later with a can-do attitude.

These are only a few ideas your knitting projects have shared with me—totally unscripted and unsolicited, of course.

Give some of these ideas a try. Your projects will thank you.

Leggy Lulu

Curl up with a book, a cup of your favorite hot drink, and enjoy these warm, chunky leggings. They're soft, comfortable, and a great gift for yourself or someone who needs a little tender loving care. (Intermediate—basic knitting skills required; you will need to know how to knit on double pointed needles)

Finished Size
Adult medium. Yarn will stretch. You can adjust the fit when you tie the ribbon).
11"/28cm (circumference) x 18"/46cm If you need a larger size, measure and increase stitches by multiples of 2.

Materials
- 1 skein Pitons Shetland Chunky, 3 1/2 oz (100g), 140 yds, (135m), 75% acrylic, 25% wool, in Amethyst.
- US size 10 (6mm) double pointed needles, or size needed to obtain gauge
- Ribbon, 1/2"/1.3cm wide, small spool (enough to finish two leg warmers)
- Large-eye tapestry needle
- Stitch markers

Gauge
15 stitches/16 rows = 4"/10cm
Always take time to check your gauge.

Abbreviations
k—knit
p—purl
st(s)—stitch(es)
DPN(s)—double pointed needles

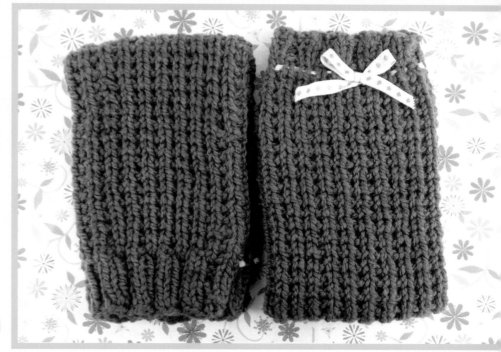

Instructions
Make 2.
Cast on 40 sts onto DPNs. Distribute sts on your needles and join without twisting. Place marker to indicate beginning of round.
Ribbing:
Rounds 1–6: k2, p2.
Round 7: k.
Round 8: k1, p1.
Repeat rounds 7 and 8 for a total of 16"/41cm from the top. (Note: now's a great time to measure leg from below knee and adjust length if needed.)
Next round: k.
Repeat ribbing rounds 1-6.
Bind off
Weave in ends.
Total length is 18"/46cm.

Finishing

Weave ribbon through legging evenly with large eye needle. I chose to weave through every 2 stitches. Leave enough of a tail to either dangle or tie in a bow.

Block if necessary.

To Block

Always check the yarn's washing, drying, and ironing instructions before blocking.

Dampen your knitted project and lay flat on blocking board or surface. Smooth to desired size and shape, and pin with rustproof pins. Let dry undisturbed overnight or until dry.

Very Berry Leg Warmers

These adorable leg warmers are Ideal for the baby in your life and make a fun baby gift for a friend. (Intermediate—basic knitting knowledge and skills are required; you will need to know how to use double pointed needles)

Finished Size

6"/15cm circumference x 7 1/2"19cm Yarn will stretch to fit. 0-6 mos

Note: Increase to a larger size by adding multiples of 2.

Materials

- 1 skein each of Caron Simply Soft Brites!, 6 oz (170g), 315 yds (288m), worsted weight 4ply in colors #9607 Limelight and #9604 Watermelon.
- US size 8 (5mm) double pointed needles, or size needed to obtain gauge
- Tapestry needle
- Stitch marker

Gauge

18 stitches/22 rows = 4"/10cm
Always take time to check your gauge.

Abbreviations

k—knit
k2tog—knit two stitches together
kfb—knit into front and back of stitch
p—purl
DPNs—double pointed needles
st(s)—stitch(es)

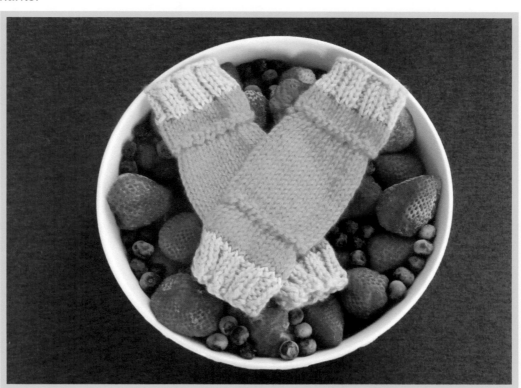

Instructions

Make 2.

Cast on 32 sts with Limelight, and distribute evenly over DPNs. Join without twisting, and place a stitch marker to indicate the beginning of the round.

Rounds 1–6: *k2, p2, and repeat from *to end. Switch to Watermelon.

Rounds 7–12: k all stitches.

Round 13: *k2tog, and repeat from * to end.

Round 14: *kfb of each st to end of round.

Round 15: p all stitches.

k every round for 3"/8cm.

Repeat rounds 12–15.

k 4 rounds.

Switch to Limelight, and k2, p2 for 5 rounds.

Bind off in pattern (knit the knit sts and purl the purl stitches as you bind off) and weave in ends.

To Block

Always check the yarn's washing, drying, and ironing instructions before blocking.

Dampen your knitted project and lay flat on blocking board or surface. Smooth to desired size and shape, and pin with rustproof pins. Let dry undisturbed overnight or until dry.

Make a Wish Wristlet

You'll enjoy this sleek wristlet with enough room for your essential items. (Intermediate—basic knitting skills required; you will need to know how to knit on double pointed needles)

Finished Size
9"/23cm x 5"/13cm

Materials
- 1 skein Caron Simply Soft, 6 oz (170g), 315 yds (288m), worsted weight, 4 ply, 100% acrylic in Bone (9703).
- 1 pair US size 8 (5mm) needles and US size 8 (5mm) double pointed needles, or size needed to obtain gauge
- Tapestry needle
- Stitch markers
- Optional materials: 9"/23cm x 15"/38cm piece of fabric or felt, fabric glue, sewing needle, matching thread.

Gauge
16 stitches/24 rows = 4"/10cm
Always take time to check your gauge.

Abbreviations
k—knit
p—purl
p2tog—purl two stitches together
yo—yarnover; wrap yarn around right needle before inserting it into next stitch
DPNs—double pointed needles
st(s)—stitch(es)

Instructions
Cast on 36 sts.
k every row for 12"/31cm.
Next row and following 2": k1, *yo, p2tog, repeat from * to last st, k1.

k the next 6 rows.
Bind off and weave in ends. Block if necessary.
Total length is 15"/38cm

To Block

Always check the yarn's washing, drying, and ironing instructions before blocking.

Dampen your knitted project and lay flat on blocking board or surface. Smooth to desired size and shape, and pin with rustproof pins. Let dry undisturbed overnight or until dry.

Make I Cord Wristlet Strap (short)

Using your DPNs, cast on 3 sts (you can use 3 to 5 sts when making an I Cord).
Knit one row, but don't turn your work. Just slip your knitting to the other end of your DPN, and work the "wrong" end of your knitting.
Pull the yarn tightly along the back of your knitting, and continue to the next knit row. Repeat for 12"/30cm. Pull the working yarn tightly along the back of your work and knit the next row.

Make I Cord Wristlet Strap (long)
Same as I Cord for short strap. Total length will be 24"/61cm.

Optional Finish: Sew felt or fabric into the inside. Tip: try fabric glue to keep in place; let dry and secure with matching needle and thread. You will need to center an 9"/23cm x 15"/38cm piece of fabric or felt on your knitting and adjust as desired. You might like to center material and have 1/4"/6.35cm seam allowance rather than trying to bring the fabric all the way to the edge of your knitting.

Fold clutch into three sections and adjust as desired. Seam sides evenly on the wrong or non-public side.

Attach straps on the inside at least ¼"/6.35cm in from the side(s).

Merry Meet Market Tote

Meet friends for lunch, shop, and run your errands with this roomy, durable, and fun market tote bag. (Intermediate—basic knitting and crochet skills required; you will need to know how to knit on double pointed needles and circular needles)

Finished Size
16"/41cm x 18"/46cm

Materials
- 1 skein Red Heart TLC Essentials, 6 oz (170g), 312 yds (285m), worsted weight medium, 100% acrylic, in Robin Egg.
- 1 skein Red Heart TLC Essentials, 4.5 oz, (127g), 245 yds (224m), worsted weight medium, 100% acrylic, in Surf & Turf
- US size 8 (5mm), 24"/61cm circular knitting needles; US size 8 (5mm) double pointed needles, or size needed to obtain gauge
- US size I–9 crochet hook
- Tapestry needle
- Stitch markers
- 2 large wooden beads to string onto yarn

Gauge
17 stitches/23 rows = 4"/10cm
12 single crochet and 15 rows = 4"/10cm
Always take time to check your gauge.

Abbreviations
k—knit
p—purl
sc—single crochet
yo—yarnover; wrap yarn around right needle before inserting it into next stitch
psso—pass slipped stitch over
sl1—slip 1 stitch onto right needle knitwise
ws—wrong or nonpublic side

Instructions
Cast on 120 sts onto your circular needles with Surf & Turf, and join without twisting. Place a stitch marker to indicate beginning of round.
k every round for 5"/13cm.
Switch to Robin Egg.
Rounds 1–3: k.

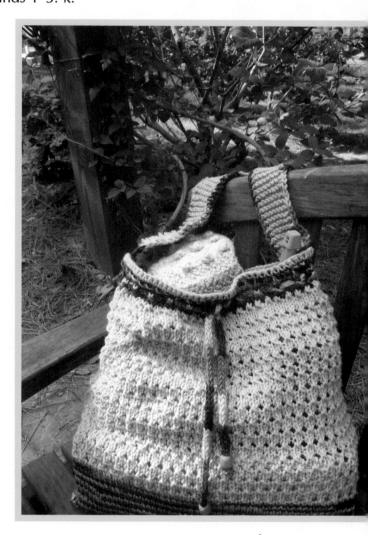

Round 4: *k1, yo, sl1, k1, psso, repeat from * to end of row.
Repeat rounds 1–4 for 12"/31cm.
Switch to Surf & Turf and continue rounds 1–4 in pattern.
k the last round.
Bind off.

Make Strap
Cast on 8 sts with size 8 (5mm) straight needles or your double pointed needles. K every row for 24"/61cm. Bind off. Weave in ends. Single crochet around the strap and allow 3 scs in each corner. Attach to the sides of your bag on the ws.

I Cord Drawstring
Using your size 8 (5mm) DPNs, cast on 4 sts (you can use 3 to 5 sts when making an I Cord).
Knit one row, but don't turn your work. Just slip your knitting to the other end of your DPN, and work the "wrong" end of your knitting.
Pull the yarn tightly along the back of your knitting, and continue to the next knit row. Repeat for 52"/132cm. Pull the working yarn tightly along the back of your work and knit the next row.
Leave a tail on both ends for your beads. You may also single crochet a drawstring if you prefer.
Turn your work inside out (WS) and seam the bottom with matching yarn.

Finishing
Single crochet along the edge of the bottom with matching yarn.
Single crochet along the top edge with matching yarn.
Weave in ends.
Block if necessary.

To Block
Always check the yarn's washing, drying, and ironing instructions before blocking.

Dampen your knitted project and lay flat on blocking board or surface. Smooth to desired size and shape, and pin with rustproof pins. Let dry undisturbed overnight or until dry.

Molly's Blanket of Hope

Recently, a neighbor's dog, named Molly, died of cancer. Molly was an older rescue dog, who was very sweet and calm. My Molly, a very friendly Yorkie, always enjoyed meeting her on her daily walk, and they became friends.

Molly's human was really sad when she died. There's nothing you can say, really, to make a dog owner feel better about their loved one's passing. I wanted to knit a blanket for a dog in need and in Molly's memory to make her feel better. I decided to take action and contacted, Linda Blick of Tails of Hope.org (Blanketed with Love Campaign) and let her know the situation. Linda was very helpful and in need of a larger blanket for a dog in hospice. I started knitting right away.

While I was working on the blanket, two neighbor children came up to my little Molly to pet her and told me all about the neighbor's Molly dying. It was very much on their minds and made them very sad.

I sent Molly's mom a note, along with a picture of Molly's blanket. Linda had sent me a photo of the dog in Molly's blanket, along with a note of how much the owner and dog loved it. My husband, Dave, later saw Molly's mom on a walk. She had tears in her eyes when she thanked him for the blanket and the note.

I realized how much we touch people's lives, whether it's through our actions, pets, or knitting projects. This is definitely something for us to consider as knitters. Every time we create an item for someone else, our stitches are knit with intent, and every project has its own history.

Enrich your life and others' with your stitches.

Autumn Suede Purse

You're ready for all the festivities of the autumn season with this suede purse.
(Easy—basic knitting skills required)

Finished Size
8"/20cm x 7"/18cm

Materials
- 1 ball Lion Brand Suede Yarn, 3 oz (85g), 122 yd (110m), weight category: 5, bulky: chunky, craft, rug yarn, in Olive.
- 1 pair US size 9 (5.5mm) needles, or size needed to obtain gauge
- Tapestry needle
- Pendant of choice

Gauge
12 sts/18 rows = 4"/10cm
Always take time to check your gauge.

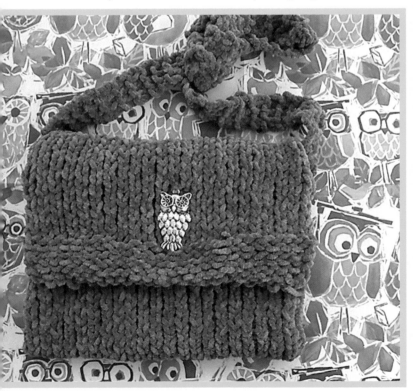

Abbreviations
k—knit
p—purl
rs—right or public side
ws—wrong or nonpublic side
st(s)—stitch(es)

Instructions
Cast on 24 sts.
Rows 1–6: p.
k in stockinette stitch (knit 1 row [rs], purl 1 row [ws]) for
20"/50 cm from the cast on edge.
Bind off.

Make strap.
Cast on 4 sts.
k every row for 36"/91cm.
Bind off.
Weave in ends. Block if necessary.

To Block
Always check the yarn's washing, drying, and ironing instructions before blocking.

Dampen your knitted project and lay flat on blocking board or surface. Smooth to desired size and shape, and pin with rustproof pins. Let dry undisturbed overnight or until dry.

Finishing
Fold into three sections as desired. Seam the sides on the ws, or non-public side and attach straps on the inside ¼"/.6cm from the edge. Attach a pendant on the front where desired.

Exercise Mat Carrier

Get fired up to go to your exercise class with this colorful mat carrier.
(Intermediate—basic knitting knowledge and skills are required; you will need to know how to knit with double pointed needles and to single crochet)

Finished Size
14"/36cm circumference x 30"/76cm

Materials
* 1 skein each, Valley Yarns Berkshire Bulky, 3.53 oz (100g), approx. 108 yds (98.76m), 85% wool, 15% alpaca, in Turquoise, Lime, Periwinkle, and Orange.
* US size 10 (6mm) double pointed needles, or size needed to obtain gauge
* 1 pair US size 10 (6mm) straight needles, or circular needles if you prefer straight needle option, or size needed to obtain gauge.
* large-eye tapestry needle
* Size G crochet hook (used to catch dropped stitches)

Gauge
13 stitches /19 rows=4"/10cm
Always take time to check your gauge.

Abbreviations
k—knit
DPNs—double pointed needles
st(s)—stitch(es)
sc—single crochet

Instructions
Cast on 46 sts with Periwinkle and join without twisting yarn. Place a stitch marker to indicate beginning of round.
Knit in the round for 3 1/2"/8.9cm
Switch to Orange, and knit in the round for 3 1/2"/8.9cm.
Switch to Lime, and knit in the round for 3 1/2"/8.9cm.
Switch to Turquoise, and knit in the round for 9"/23cm.
Switch to Lime, and knit in the round for 3 1/2"/8,9cm.
Switch to Orange, and knit in the round for 3 1/2"/8.9cm.
Switch to Periwinkle, and knit in the round for 3 1/2"/8.9cm.
Bind off.
Weave in ends.
Total length is 30"/76cm.

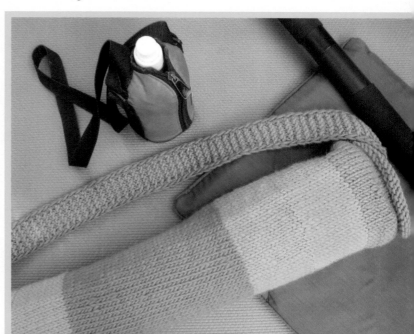

Shoulder Strap

Cast on 6 sts of Periwinkle.
Knit every row for 28"/71cm, or length desired. Bind off and weave in ends. Crochet a sc border with Turquoise. Start on the right hand corner and sc 3 sts in all four corners. Sc edge and continue in this manner until you have gone around the entire strap. Attach your Velcro dots or strip on the non-public side of your strap.

Bottom

Use Lime yarn and cast on 15 sts and knit in stockinette stitch for 20 rows on 10 ½ knitting needles. You can use straight needles if you desire. This will create a square shape to fit inside of your tube. Attach the square securely with yarn making sure the knit side is on the public side of the tube and the purl side is facing you on the inside of the tube.

Attach shoulder strap to the inside edge of the top of tube and at the bottom with Turquoise yarn.

Straight Needle or Circular Needle Option

Note: Work back and forth on circular needles without joining (as if they were on straight needles). Cast on 46 sts with Periwinkle and knit in stockinette stitch for 3 ½"/8.9cm.
Continue to knit in stockinette stitch and switching colors as in option one. If you are using circular needles, you will not join sts together.

Bind off.
Seam the side edges together.
Total length 30"/76cm.

Follow previous instructions to make the bottom and shoulder strap.
Block if necessary.

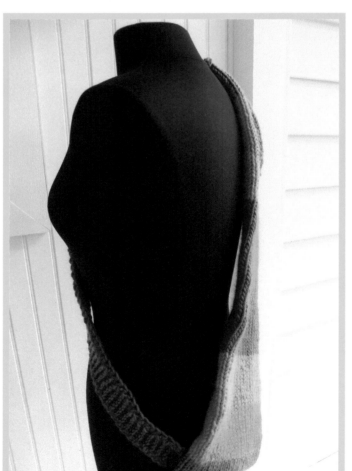

To Block

Always check the yarn's washing, drying, and ironing instructions before blocking.

Dampen your knitted project and lay flat on blocking board or surface. Smooth to desired size and shape, and pin with rustproof pins. Let dry undisturbed overnight or until dry.

Cotton Bobble Throw

This lightweight, colorful, and portable throw is perfect for baby or small dog and the perfect small project to take along in your project bag.
(Intermediate—basic knitting knowledge and skills, plus you will need to seam together the squares and knit bobbles; instructions are included)

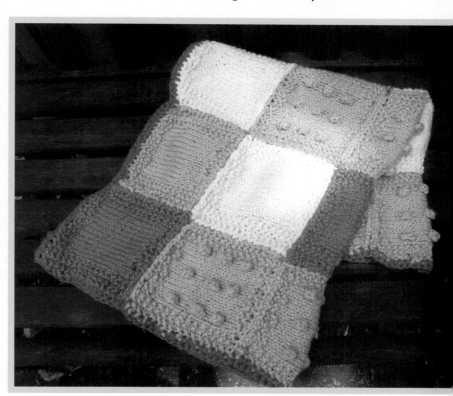

Finished Size
30"/76cm × 30"/76cm

Materials
- 2 skeins each of Nature's Choice Organic Cotton, 3 oz (85g), 103 yds (94m), weight category: 4 medium: worsted weight, afghan, aran yarn, 100% organically grown cotton, in Almond, Blueberry, Dusty Sage, and Olive.
- 1 skein of Nature's Choice Organic Cotton, in Spice
- 1 pair US size 9 (5.5mm) needles, or size needed to obtain gauge
- Size J–10 crochet hook
- Tapestry needles

Gauge
14 stitches/20 rows = 4"/10cm
10 single crochets/12 rows = 4"/10cm
Always take time to check your gauge.

Abbreviations
k—knit
p—purl
k2tog—knit 2 stitches together
st(s)—stitch(es)

Knitted Squares
Make 6 squares in Almond, 6 in Olive, 2 in Blueberry, and 2 in Dusty Sage. Each square should be 6"/15cm x 6"/15cm.

Cast on 20 sts.
Rows 1–4: * p1, k1, p, repeat from * to end of row.
Row 5: *p1, k1, p1, k, repeat from * to last 3 sts, p1, k1, p1.
Row 6: p1, k1, p1, p to last 3 sts, p1, k1, p1.
Repeat rows 5 and 6 for 5"/13cm.
Repeat rows 1–4.

Bobble Squares
Make 5 in Blueberry and 4 in Dusty Sage.

Bobble Stitch (small)

Knit into the front and back of your knit stitch, turn and purl, turn again and knit, turn and purl, turn and k2tog, and knit into the next stitch. Push your bobble through your knitting.

Row 1–4: *k2, p2, repeat from * to end of row.
Row 5: k2, p2, k to last 4 sts, k2, p2.
Row 6: k2, p2, p to last 4 sts, k2, p2.
Repeat rows 5 and 6 once more.

Start a bobble row.
K2, p2, make first bobble, k4, make 2nd bobble, k4, make 3rd bobble.
Next row: k2, p2, p to last 4 sts, k2, p2.
Next row: k2, p2, k to last 4 sts, k2, p2.
Repeat last two rows.

Repeat bobble row sequence twice more.

Repeat rows 1–4.
Bind off in pattern. Knit the knits and purl the purls.

Assemble squares using chart provided. Seam squares with leftover yarn on the wrong, nonpublic side. Use Spice to sc along the edge.

Block if necessary.

To Block

Always check the yarn's washing, drying, and ironing instructions before blocking.

Dampen your knitted project and lay flat on blocking board or surface. Smooth to desired size and shape, and pin with rustproof pins. Let dry undisturbed overnight or until dry.

Knit Squares

 6 each in Almond
 2 each in Blueberry
 2 each in Dusty Sage
 6 each in Olive

Bobble Squares

 5 each in Blueberry
 4 each in Dusty Sage

<	#	X	O	<
1	X	2	<	1
2	#	1	X	2
1	X	2	#	1
X	O	<	#	x

Key:
X Knit Almond Square
O Knit Blueberry Square
Knit Dusty Sage Square
< Knit Olive Square
1 Blueberry Bobble Square
2 Dusty Sage Bobble Square

Knitavian Shruggle Bonus Pattern

This lightweight shrug is just the right wrap all year long.
(Intermediate—basic knitting skills are required; you'll be knitting back and forth on the circulars and will seam the shrug)

Finished Size
34"/86cm× 8"/20cm (the shrug is intended to be loose-fitting)

Materials
- 4 skeins of Naturally Caron Country, 3 oz (85g), 285 yds (170m), 25% merino wool, 75% microdenier acrylic, in Peacock
- US size 9 (5.5mm) circular knitting needles with 24"/61cm or 29"/73cm cable, or size needed to obtain gauge
- Tapestry needle
- Size I crochet hook to pick up dropped stitches
- Stitch markers

Gauge
16 stitches/24 rows = 4"/10cm
Always take time to check your gauge.

Abbreviations
k—knit
p—purl
p2tog—purl two stitches together

yo—yarnover; wrap yarn around right needle before inserting it into next stitch
RH—right hand
st(s)—stitch(es)

Instructions
Cast 136 sts onto your circular needles, but do not join. Work back and forth as if the stitches were on straight needles.

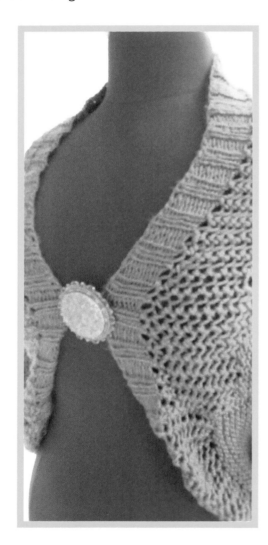

Ribbing:

Row 1: *k2, p2, repeat from * to end of row.

Row 2: k the k sts and p the p sts.

Repeat rows 1 and 2 for 2"/5cm.

Next, *k1, yo, p2tog, repeat from * to the last st, k1.

Repeat for 3"/8cm.

Next, k in stockinette stitch (k 1 row, p 1 row) for 3"/8cm.

Repeat the previous two rows for a total of 34"/86cm.

Repeat ribbing for 2"/5cm.

Finishing

Fold your knitted shrug in half. Bring the cast-on edge and bound-off edges together, to measure 34"/86 cm× 8"/46 cm. Place your stitch markers 18"/46cm on each of side of the shrug along the bottom edge. Next, place another marker 7"/18cm up from the bottom edge on each side for armhole openings. Now you're ready to seam the sides, from marker marker. Weave in ends. Block if necessary.

To Block

Always check the yarn's washing, drying, and ironing instructions before blocking.

Dampen your knitted project and lay flat on blocking board or surface. Smooth to desired size and shape, and pin with rustproof pins. Let dry undisturbed overnight or until dry.

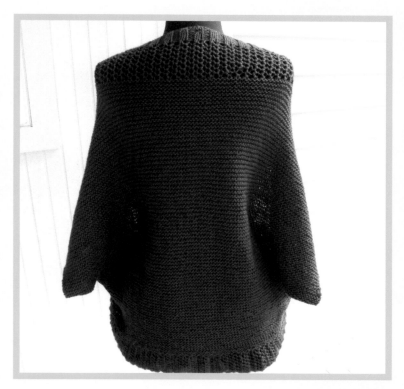

Interviews

Gather 'round the knitting couch for these inspiring interviews with Rachel-Marie of Knittydirtygirl. com, Christine Shively of Knots-of-Love.org, and Althea Crome of Bugknits.com. Althea was a knitwear designer for the movie *Coraline* and originally interviewed on my blog, *Knit1fortheroad soon after the premier of Coraline.* It was a wildly popular interview, so I have included it here for you. Click your needles and wave your hooks for these wonderfully creative and dynamic women.

Rachel-Marie of Knittydirtygirl.com

Q. What inspired you to start your business, KnittyDirtyGirl.com, and when did you begin?

A. One word. Pluckyfluff. Lexi has inspired a whole army of fiber artists, and we are thankful!

Q. Anyone who has visited your shop is struck by the creativity and love that you put into your business. What are your favorite items that you make?

A. I go through phases. Currently I am most thrilled and excited while spinning my luxury, arty, fine, two plies. I mix local baby alpaca roving with my textured batts by spinning them in two very thin singles. I alternate between batt and roving in each single; when they are plied together—magic.

Q. You seem to have integrated your business and love for fiber art. How do you balance family and business?

A. It's so hard. For a while, I could spin with Octavian in my sling, but once he hit toddler stage, that was all over. I work part time at a swanky yarn shop; my boss lets me spin there. Yes, I said it … *she lets me spin at work.* I get paid hourly to spin my own yarns at the LYS, which definitely helps me balance my family life at home. There are certain times of the year, however, where the laundry piles up, and we eat a lot of grilled cheese. Such is life!

Q. Are any of your items available in stores?

A. Yes, many retailers, but my most stocked and current favorites are Lancaster Yarn Shop (two locations), http://lancasteryarnshop.com, in Pennsylvania. And Urban Fauna Studio in San Francisco, California, http://urbanfaunastudio.com.

Q. How did you react when supporters started the knittydirtygirl Ravelry group, of which I am a proud member?

A. I was so thankful! It's wonderful to have a place to connect with my friends and customers. I feel so comfortable there, able to "pimp" my work and update everyone without feeling "spammy."

Q. What are some tips that were essential for you, and that you would like to share with the readers, regarding building and sustaining a successful business?

A. Keep trying, keep trying, don't give up, never give up. The more you put into your business, the more you will get out. The longer you keep at it, the more it will build. Have faith in yourself.

Q. Every time I visit your shop, there are new categories and items. I especially enjoy the artwork, wearable, and clubber sections. What was your inspiration for including these categories in your shop?

A. I guess it's the inner child in me. I like to make things for myself, even though they may not always be super profitable. It always excites me when someone buys a notebook with one of my silly doodles! Or the fact that I can list an intergalactic scarf and, if nothing else, it will be there to raise an eyebrow. I think having other items in my shop inspires people, gives them an idea or two of how they can use yarn in a different way.

Q. As an artist who is involved in your community, what is your favorite way to increase the public's awareness of fiber arts?

A. I love to communicate with our local customers on Ravelry. We have a Lancaster PA group and a Lancaster Yarn Shop group. I feel like I get in touch with the local people the best when I snag an interview in the Lancaster newspaper. Of course, I am a little hipster market townie. I go to Eastern and Central Market weekly and all of the indie local spots. I am also a member of my beloved Lancaster Indie Arts, http://lancasterindiearts.com. We do group shows in local coffeehouses and bookshops. Locals are always asking me what I'm knitting or spinning, and I'm always asking them what they're making, too.

Q. How do you keep your energy level up for your busy life?

A. Coffee, naps, and venting.

Q. Do you have any additional information you would like to mention?

A. None that I can think of! I keep an alarmingly detailed blog on my life. A mix of local indie arts, family, and fiber, http://knittydirtygirl.livejournal.com.

Thank you, Rachel-Marie for taking time for the interview and for giving us a glimpse into your hipster life.

Christine Shively, Founder of Knots of Love.org

Q. Christine, please tell the readers what inspired you to create Knots of Love.org?

A. I took up crocheting after many years of not picking up a hook and was looking for a way to use the vast number of hats I was making. A friend who had survived cancer said she would have liked a cozy hat to wear when she took off her wig at night, and thus, the nonprofit charity was born.

Q. Tell us where and how your caps are distributed, and do you take requests from individuals?

A. KOL has members all over the country who send caps to me. The caps are distributed to cancer centers, oncologists' offices, and infusion centers all over the U.S. The caps are also donated to anyone suffering from a life-threatening illness, not just cancer patients. I have many requests from individuals who are in need of some kindness.

Q. What direction do you see Knots of Love going in the future?

A. Knots of Love has grown beyond my wildest imagination. After seeing how this has positively affected cancer patients, nursing staffs, and the knitting and knotting volunteers, we are committed to expanding our efforts. I am certain, with more awareness and members, we will continue to create caps and continue to grow at a rapid pace.

Q. How do you find time to create the caps you make, and do you knit and/or crochet?

A. I am a knotter (crocheter). I am able to make the time to knot at least one cap a night. If you want to do something badly enough, you will make the time.

Q. Please tell us about the amazing responses you've had to the caps that you and your knitters and knotters (crocheters) have made.

A. I receive letters, e-mails, and even phone calls daily from patients, nurses, and family members thanking the Knots of Love Team. Recipients of our caps are amazed that people they will never know care enough to make a cap especially for them.

Q. How can readers participate in contributing either caps or donations?

A. Please visit our Web site, www.KOLinfo.org, to learn how easy it is to donate caps or to make a donation. If you don't have Internet access, you can simply mail your caps to Knots of Love, Inc., 445 Seville Ave., Newport Beach, CA 92661.

Q. Christine, you are so energetic and motivated. What inspires you the most?

A. I walk into a doctor's office or hospital with a bag of caps and see the patients straining from their infusion cubby to see what I have. It is not unusual for a patient, nurse, or doctor to give me a warm, grateful hug. A simple thank you on a sticky note received in the mail. That's motivation enough for me and for all KOL members.

Q. What do you think is the key ingredient to your success?

A. I surround myself with positive people with warm, loving hearts.

Q. Do you currently have a favorite pattern or yarn that you are using for your caps?

A. Yes, I have two patterns. One knitted pattern and one knotted pattern. Caron Simply Soft Yarn is a fabulous yarn, soft enough for sensitive bald heads and very economical.

Q. Christine, is there any additional information that you would like to share with us that was not covered in this interview?

A. We need more members. The more caps I receive, the more lives we can touch and continue to put smiles on faces that need a reason to smile. Hey, we also make guy's caps!

Thank you for sharing with us, Christine.

Althea Crome, Bugknits, and Coraline

The following interview first appeared on my blog, *Knit1fortheroad*, on February 11, 2009.

Today, it is my honor and thrill to present the interview with the incredible Althea Crome of Bugknits. com, miniature knitting artist extraordinaire, who designed knitwear for the character Coraline. The amazing Althea Crome shares her inspiring, magical, and exciting knitting adventure.

Q. Althea, I have to start off asking about your knitwear for Coraline. What a thrilling opportunity for you. How did it come about?

A. You could not be more right. This was indeed an absolutely thrilling opportunity for me and without exaggeration, a life-changing experience. About three years ago, while sitting at an outdoor Thai restaurant with my mom, lamenting the break up of my marriage, I got an unexpected phone call from Shere Coleman from the costume department at Laika Studios. She explained that Laika Studios (previously Will Vinton Studios), which had been recently purchased by Phil Knight, was making its first feature-length animated movie. She told me how the movie they were making was based on a book called *Coraline* by Neil Gaiman (who, I admit, I had not heard of yet) and about Henry Selick, who was the mastermind behind *Nightmare Before Christmas*. She told me about how many of the costumers had come from England and had worked on *Corpse Bride*, which my children and I loved.

She said that they had always wanted miniature knitting for their movies but never had anyone who could knit at that scale. They decided to do a Google search, and they came across my Web site. They said that because the plot of the story had a mystical quality, they were looking for knitting which had a magical quality and they really felt that my designs filled the bill.

Shere asked if I was interested in doing commissions. At the time, I was so overwhelmed with trying to raise four children on my own and figure out how to make a living, I wasn't sure I could take on commission work, but I asked Shere to send me a follow-up e-mail, which, thankfully, she did.

I recognized soon enough that this was a really special project and that I would be a fool to turn it down. I simply *had* to find the time to fit it in. The first request from the studio was to knit a pair of black and white striped stockings for Coraline. Henry Selick loved them and even said they were "scary good," but in the end, they decided not to use them in the movie. Instead, they told me about the magical star sweater they needed. It would have to sparkle. I went on a tireless thread quest for about a month—finding everything from stainless steel thread to paintable sparkles—and then set about knitting swatches and sending them to Laika. None of them looked right onscreen, and because of a time issue, it was looking like my hopes of making something for this wonderful project were fading. In fact, at one point, they told me that they were going to have to start shooting soon and would not be able to wait for me to find the right combo of threads. Soon after that e-mail, my mom came over with some holographic thread and said, "Althea, I really think this will work on the sweater for Coraline." I combined the holographic thread with some polyester sewing thread and sent off several more swatches to the *Coraline* people. Eureka! That was the ticket, and at the 11th hour, Henry decided to have me go ahead and knit up the first star sweater for *Coraline*.

At that point, the studio sent me a Coraline body to fit the sweater onto and a drawing of what they wanted the sweater to look like. I designed a pattern that would fit the willowy Coraline, and it took about 2 weeks to knit the sweater. I was delighted when I got the thumbs up from the studio, and over the next couple of years I made a total of 14 identical sweaters for *Coraline*.

I was also thrilled to learn that they would need a pair of gloves for Coraline, because gloves are my favorite thing to knit. They are so intricate and personal and somehow very intimate. Knitting gloves in 1/12 scale was what got me noticed in the miniature world, because up until I started knitting them, miniature collectors had never had true 1/12-scale knitted gloves.

There are only two knitted garments in the film—the star sweater and the gloves—both of which are special because they are given to her by her mothers: the star sweater is given to her by her Other Mother, while the gloves, which she really wants and covets, are given to her by her real mother.

Q. What were you feeling when you were in Portland, Oregon, for the world premiere of the movie?

A. The thing I felt the most going to the world premiere of *Coraline* was that I was so lucky! Of course I felt very nervous, too, because I knew I was going to be working at the party, showing off some of the knitwear I made for the movie, talking to a bunch of the VIPs and possibly even some movie stars. Gulp! I'm just a hardworking Midwesterner, and this was my first red carpet event. What I did not expect was how wonderful, gracious, and warm everyone was. I think the fact that the premiere was in Portland, rather than LA, gave it a really special but more relaxed and Bohemian feeling. It was magical, like the movie itself. There were people there dressed in jeans, there were people there dressed in vintage gowns, and there were people there dressed to the nines: all sorts of people from all walks of life, enjoying a really special night together. The party concept was genius. It really showcased the amazing handwork that went into the making of this movie and also emphasized the colossal team effort required to make such a film. There are clearly many, *many* cooks in the kitchen, and yet somehow, they managed to organize it and pull it all together to create something spectacular, unified, and glorious, much of which has never been seen on the big screen before. I confess I was starstruck at first. But then people started coming over to me and offering heartfelt thanks and congratulations for my contribution to the film. Neil Gaiman and his wonderful daughter, Maddie, were the first to come by and visit. He was so kind and lovely and so very complimentary of my work. Then Travis Knight came by and said that he has been in the business for a very long time, and he has never seen the kind of attention to detail he saw in my knitting. I was absolutely humbled and grateful for his kind words. I was surrounded all night by people who wanted to watch me knitting, who wanted to see my art, who wanted to tell me "thank you." I must say, it ranked right up there as one of the best nights ever.

Q. What a wonderful experience. I have to say, I totally love the blue sweater with stars on Coraline. Is this item going to be made available in full scale to all the millions of children who are going to see the movie?

A. If Laika wants me to do a full-scale version, I would be delighted. I have not, as of yet, designed one but would certainly like to for my daughter and nieces.

Q. What was the actual size for the Coraline model, and how long did it take you to complete the knitwear? Were you allowed to create your own vision of what Coraline would wear, or did you work within guidelines from the producer of the movie, Bill Mechanic, or director, Henry Selick, and/or the author, Neil Gaiman?

A. Coraline is about 9 inches tall. She is incredibly willowy and has a very big head compared to her lithe body. Coraline's star sweater is made up of four pieces: front, back, and two sleeves. It took me 2 weeks to knit each sweater. The costuming department took the pieces and sewed the seams together while it was on the puppet (therefore, I could not have knit it in the round), and they also applied the glow-in-the-dark stars. The conceptual design for the sweater came totally from Laika. They sent me a picture and a color swatch. The rest was up to me. I worked closely with Georgina Haynes, Margaret, and Deborah Cook in the costuming department. I had the opportunity to visit the set of *Coraline* in October of 2007, and I also got to sit in on a meeting with Henry Selick, where he was viewing some of the daily footage. (The day I was there, they were looking at the scene where the Other Mother eats one of the cocoa beetles. I was very impressed with the level of attention they gave to the chewing and the swallowing.) Henry took the opportunity to tell me how special my contribution to the film was. He told me that he thought it added something truly special.

Q. What inspired you to knit in miniature?

A. Although miniatures had always held a sort of fascination for me, I had never entered that world, or had a dollhouse, or even knew that a whole industry revolving around miniatures really existed. In 2001, one of my best friends kept telling me about a dollhouse she had rescued from the garbage. When I finally went to visit her in Philadelphia, she showed me the house, which she was in the process of remodeling, and it looked like fun. When I got home, I decided I would take on a dollhouse project of my own, ostensibly for my children when they were a little older. In my efforts to fill the dollhouse with things (I shopped mostly on eBay then, since I was homebound with kids and really knew nothing of miniature shows or dollhouse shops), I came across a knitted sweater on eBay and thought, *Hey, I want to try that*. I have been an avid knitter since my college days and thought I could do at least as well as I had seen online. That very night, I made a man's cardigan with 0 needles and baby weight yarn. It was bulky and clumsy, but it was an instant thrill. I felt at once that I had to do more. I still have that first project and enjoy pulling it out from time to time to look at it and see how far I've come. That sweater is made at about 11 stitches per inch, whereas the sweaters I make now often have more than 50 stitches per inch. After I had made a few things, I decided to try selling them on eBay, and though that venture did not exactly pan out monetarily, it did get me connected to some people in the field. One connection led to another, and within about a year or two, I had met some famous miniature artists, who were taking some of my knitted garments to shows to sell. I was getting some really positive feedback, and people really loved my knitting. Eventually, once my children were a little older, I started attending shows myself.

Q. Althea, how did you come up with the name of your Web site, Bugknits.com?

A. That's an easy one. My dad dreamed it up for me. He's always been great with names.

Q. Do you have any tips for the readers for balancing family life, knitting, and business? Have your children read *Coraline*?

A. I've never been that great at "balancing" things in my life. I tend to go to extremes. Like staying up until 3 in the morning so I can get a good eight hours of knitting in for the day. I can say this: one thing I have learned through this process is that it is *never* too late to follow your passion in life. That no matter what all the naysayers may throw at you, if you are passionate about something, and good at it, then take the chance and pursue it, regardless of whether or not it is financially viable at the time. Granted, not all of us have the luxury to pursue art in lieu of making a living, and I am no exception. I live very close to the ground, so to speak, but I believe that some day my hard work and my love of the craft will pay off financially. My children are absolutely delighted with *Coraline* and have already seen it twice. Next, I'll be taking them to Indianapolis to see the 3-D version. This year I got to be *Coraline's* knitwear creator *and* have a two-page spread in Ripley's Believe it or Not's last book (*Prepare to Be Shocked*), so they have a lot to boast to the kids at school about!

Q. What are your favorite subjects for your knitting at this point in your creative process?

A. I am in love with designing conceptual knitwear. I get visions in the shower, while falling asleep, while driving, and I can't wait to get home, draw it out, and then chart it. I know that once I can chart something, I will be able to make it. I design all my garments so that the shape compliments the pictorial theme knitted into the garment. For example, the Ancient Greek Amphora I and II are decorated with all kinds of Greek imagery, warriors, boxers, and bullfighters. But the shape of the garment, while still recognizable as a sweater, is that of a Greek vase with a tall neck and ornate foot and sleeves that look like handles. The King and Queen of Hearts sweater has a collar shaped like a crown and sleeves that flair out like a royal robe. The Scuba sweater (a narrative story about a day I spent diving in Key Largo) has a collar designed to look like a barrel sponge and borders on the edge of the cuffs and bands to look like the waves of the ocean. My Andy Warhol sweater, with Marilyn Monroe on the back, has soup can on the front for pockets (the lids open up to reveal the pocket opening). I have several new ideas, which are all in various states of completion; some are still just concepts. (I intend to design and knit a 3-D Roman relief sweater.) Other ideas are charted out, awaiting the first knit, like my medieval nativity scene conceived of as a triptych.

Q. Do you have any dreams, goals, or plans in 2009 for yourself and/or the business that you would like to share with us?

A. My dream is to be able to continue to follow my passions designing and knitting in 1/12th scale. I have so many concepts for new sweaters. A Roman relief, a family of nudes, a dragon, and a medieval nativity scene are just a few. So many ideas, so little time. I would also like to do some traveling and presentations. I will be at the National Museum of Women in the Arts on May 9th and at the Columbus Library in Columbus, Indiana, in September. I'm also thinking of writing a book of patterns and taking my miniature patterns and upscaling so they can be knit for real humans. And I would love to work on another movie again. The *Coraline* project was one of the best jobs I've ever had, and I really liked working with those great creative minds.

Q. Althea, thank you so much for taking time away from your busy life to be interviewed for the *Knit1fortheroad* readers. Is there anything else you would like to add about yourself and/or Bugknits?

A. It's been my pleasure. If you need any other information about what kinds of things I've been up to or what books, magazines, or articles I've been in, you can check out my résumé online. http://www.bugknits.com/Resume.htm

I was in the last Ripley's Believe it or Not (*Prepare to Be Shocked*) and Sabrina Gshwandtner's book, *Knitknit: Profiles and Projects in Knitting's New Wave*. This year, I will be in a book called *The Culture of Knitting*.

Althea, it has been my pleasure to interview you and share your wonderful journey with the readers. It is such an inspiring story and message for everyone out there pursing their passion and their dreams. Thank you.

Visit: Bugknits.com, Radical Lace and Subversive Knitting Exhibit.

Charity Resources

Are you looking for a reliable knit and crochet charity? Here are a few organizations that will make sure your knit or crochet item will reach those in need.

Afghans for Afghans.org

Afghans for Afghans.org reaches out to send care to those families in need in the rough and war torn country of Afghanistan. They feature reports and photos of recipients of your hand-knit or hand-crocheted items as well as beautiful patterns. You will also be able to use wool yarn due to the nature of the environment where they are being sent.

Craft Hope.com

Craft Hope is one of the most inspiring and crafty ways to help make the world a better place. The projects are ongoing, fun, and crafty. Make each project a family event.

Friendship Shawl.org

Friendship Shawl.org is a site Warm Up America started for knitters and crocheters interested in making shawls for those in need in hospitals and nursing homes. Their site has patterns and stories of what the shawls mean to those who receive them.

Knots of Love.org.

This organization sends your hand-crocheted or hand-knitted chemo cap to those in need. During the summer months, the cotton and cotton blend caps are in high demand. Their site has free patterns for you and information about the organization. You will also receive updates from Christine Shivley on the organization's progress as well as where your caps were sent.

Mother Bear Project.org

The Mother Bear Project provides children who need an extra dose of love and care with handmade bears. They provide clear instructions and an adorable pattern for you to follow.

Scarves from the Heart.com

Scarves from the Heart accepts scarves for cancer patients for both men and women. Please visit their site for all of the wonderful patterns and updates on what this organization is doing.

Tails of Hope Foundation.org.

The Blanketed with Love Campaign is a program that helps animals in need. Knit or crochet a blanket today!

Warm Up America! at Craft Yarn Council.com

This is a very well-known and superior organization. Their site will inspire and motivate you.

When I look for a charity to knit or crochet for, I do a little investigation to see what kind of record they have or see if they are recommended by trusted knit and crochet Web sites or friends. Many of the larger charities have nonprofit status information available. This will help you pick the right charity for you and keep your beautiful items from being sold for a profit rather than donated. There are times when charities have auctions to raise money for a cause, which is perfectly wonderful. Just make sure they are reliable, and you feel comfortable giving them your handmade items.

Ravelry groups are a good way to make friends, help others, and learn from some very creative people.

Teresita Valadez, is founder and moderator of Hearts of Love on Ravelry.com, a group dedicated to creating handmade projects for people in need. The projects vary, and there is a cause with which everyone can get involved. This interview was originally posted on *knit1forhteroad* on blogger.com on February 2, 2009.

Hearts of Love Interview

Q. Teresita, what was your inspiration for starting the amazing Hearts of Love group on Ravelry. com?

A. I have always been active in helping others with health-care information. I have coordinated several health education fairs and also have done workshops, sharing information about breast cancer education and prevention. Then, on March 18, 2008, my husband received a prostate cancer diagnosis, right on our anniversary. It changes things all in an instant. So one month, later I had begun this Ravelry group, which has evolved into what it is today, Hearts of Love, where members create chemo caps with fashion flair and radiance to brighten the days of cancer patients undergoing chemotherapy.

Q. Do you have favorite items that the group makes for cancer patients?

A. Our group enjoys making chemo caps for all ages now … infants, children, teens, and adults. There are so many children who, at such a young age, already are diagnosed with cancer. I call these little warriors "The Young and so Brave," and we actually share info with our members about children with cancers for their parents and family. In addition to chemo caps, we also make scarves, which pair up nicely with the chemo caps. Dishcloths and washcloths are also very thoughtful gifts to make as well, along with comfort shawls and lapghans. These would be our favorite items.

Q. Hearts of Love is growing by leaps and bounds. How do you juggle being the moderator with everyday life?

A. Keeping Hearts of Love active and enjoyable for our members is just part of my every day. It is a way to channel my energy into inspiring others and empowering others that we can all make a difference. You could say that, "Yes we can!" So, this is just part of my everyday life, and it brings joy into my life knowing that I, too, am doing something to fight back against all that cancer hurts and takes away from us.

Q. Do you knit and crochet? What are you currently learning or working on?

A. I crochet, knit, loom knit, and also enjoy plastic canvas needlepoint. I work on chemo caps, dishcloths, and baby items (blankies, booties, bibs, washcloths, and bibs) for my local chapter of Stitches from the Heart charity organization that I began for my community in June 2008. I am the area representative for our chapter, which meets monthly. I am also a "blanketeer" for my local Project Linus.

Q. I saw a thread called "What's Cooking," regarding recipes. Do you have any special recipes that you can recommend to take away some winter chill?

A. I do love a good bowl of 3-alarm chili. Of course, here in California, we aren't struggling with the freezing snow and harsh winter conditions, as many parts of the country where our friends do live. Our members add fun recipes to match the season or just a favorite. There are some nice recipes for Chinese New Year of the Ox and, of course, already some dinners to make for Valentine's Day.

Q. How have your group members inspired you?

A. I enjoy the personal letters that members write me and share their stories with me. I have made some wonderful friends in this group who write me often and make me very happy to be their friends. I think inspiration and joy is reciprocal: as you inspire others, it comes back to you twice over. This group is all about caring and realizing that we can all reach out and warm someone's heart in a loving way. It doesn't matter where we live or what our age or our ethnic background is. We are all connected by being here and can do so much to brighten the days of our lives.

Q. What are your favorite yarns, snack foods, and activities outside of knitting?

A. My favorite yarns are the all cotton yarns (Peaches & Crème and Sugar & Cream), along with Vanna's Choice Yarn and Caron's Simply Soft. For snack food, I love enchiladas and pizza. Besides my crafting, I love to read. I am an avid mystery reader and also an avid movie buff. Baking and cooking are also some favorites that I enjoy doing, as well. I love going to the seashore whenever I can and love knitting and crocheting there.

Q. Is there anything you would like to add that we haven't covered?

A. Taking care of ourselves is very important. We all get busy. Yet, it is very important to learn about lowering cancer risks in our own lives. There are controllable and uncontrollable risks that we face. We can fight back against cancers in learning what factors we can control. This is something that we can do.
Receiving a cancer diagnosis does change things. But it is up to us how we are going to go on with our lives and fight back to go forward. There is much more to this disease than simply the radiation and the chemo or whatever other treatment one receives. It's an entire process of being informed and the many doctor visits and then the treatment. Then there is life after treatment, which can be difficult in learning how to cope with the physical, mental, and emotional changes that we have undergone. So, being a friend and support to someone battling cancer and learning about support groups is indeed a special way that we can help others. Cancer survivors will tell you that the support they received from others was a big part of their healing and recovery. So, come on over to Hearts of Love Ravelry and visit our Hope & Support Resources for lots of very helpful resources. Each of us can really make a difference, and no amount of love is ever too small.

Thank you, Margaret, for this interview and for thinking about Hearts of Love. Glad to have you as a member and continued best of good luck with your book, and good health wishes to you.

I would like to thank the wonderful people at the Craft Yarn Council of America, www.YarnStandards. com, for the following Yarn Standards Guidelines.
Please visit their website for knitting and crochet resources and help.

Standards & Guidelines

The publishers, fiber, needle and hook manufacturers and yarn members of the Craft Yarn Council of America have worked together to set up a series of guidelines and symbols to bring uniformity to yarn, needle and hook labeling and to patterns, whether they appear in books, magazines, leaflets or on yarn labels. Our goal is to make it easier for industry manufacturers, publishers and designers to prepare consumer-friendly products and for consumers to select the right materials for a project and complete it successfully.

We urge manufacturers, publishers and designers, to adopt these guidelines. Downloads of the graphic symbols are available at www.YarnStandards.com at no charge. We ask that if you use them in any publication that you advise us in an e-mail of your intention to use them and that the following credit line be given:

Source: Craft Yarn Council of America's www.YarnStandards.com

We received valuable input from allied associations in the United States, such as The National NeedleArts Association, the Crochet Guild of America, and The Knitting Guild Association, as well as designers and consumers. Ultimately, our objective is to design global standards and guidelines that will be used by companies worldwide. To this end, we have reached out to individuals, manufacturers and trade associations in the United Kingdom, Germany, Italy, France, as well as in Australia and New Zealand to ask for their input.

Skill Levels

SKILL LEVELS FOR KNITTING

1 ▧□□□ **Beginner**	Projects for first-time knitters using basic knit and purl stitches. Minimal shaping.	
2 ▧▪□□ **Easy**	Projects using basic stitches, repetitive stitch patterns, simple color changes, and simple shaping and finishing.	
3 ▧▪▪□ **Intermediate**	Projects with a variety of stitches, such as basic cables and lace, simple intarsia, double-pointed needles and knitting in the round needle techniques, mid-level shaping and finishing.	
4 ▧▪▪▶ **Experienced**	Projects using advanced techniques and stitches, such as short rows, fair isle, more intricate intarsia, cables, lace patterns, and numerous color changes.	

SKILL LEVELS FOR CROCHET

1 ▧□□□ **Beginner**	Projects for first-time crocheters using basic stitches. Minimal shaping.	
2 ▧▪□□ **Easy**	Projects using yarn with basic stitches, repetitive stitch patterns, simple color changes, and simple shaping and finishing.	
3 ▧▪▪□ **Intermediate**	Projects using a variety of techniques, such as basic lace patterns or color patterns, mid-level shaping and finishing.	
4 ▧▪▪▶ **Experienced**	Projects with intricate stitch patterns, techniques and dimension, such as non-repeating patterns, multi-color techniques, fine threads, small hooks, detailed shaping and refined finishing.	

This Standards & Guidelines booklet and downloadable symbol artwork are available at: **YarnStandards.com**

Hooks & Needles

The Council's hook and needle manufacturers have agreed to make metric (millimeter/mm) sizing more prominent on packaging. The U.S. sizes, both numbers and/or letters, will also appear on packaging.

More prominent labeling of metric sizing, which is an actual measurement, should help eliminate consumer questions about the differences among the letter and number sizing of some needles and hooks. As noted in the introduction, with the cooperation of manufacturers, publishers and designers these changes will be implemented as packaging is reprinted and new patterns are published.

Knitting Needle Sizes

Millimeter Range	U.S. Size Range
2.25 mm.	1
2.75 mm.	2
3.25 mm.	3
3.5 mm.	4
3.75 mm.	5
4 mm	6
4.5 mm.	7
5 mm	8
5.5 mm.	9
6 mm	10
6.5 mm.	10½
8 mm	11
9 mm	13
10 mm	15
12.75 mm	17
15 mm	19
19 mm	35
25 mm	50

Crochet Hook Sizes

Millimeter Range	U.S. Size Range*
2.25 mm.	B–1
2.75 mm.	C–2
3.25 mm.	D–3
3.5 mm.	E–4
3.75 mm.	F–5
4 mm	G–6
4.5 mm.	7
5 mm	H–8
5.5 mm.	I–9
6 mm	J–10
6.5 mm.	K–10½
8 mm	L–11
9 mm	M/N–13
10 mm	N/P–15
15 mm	P/Q
16 mm	Q
19 mm	S

*Letter or number may vary. Rely on the millimeter (mm) sizing.

NOTE ABOUT STEEL HOOKS: Steel crochet hooks are generally used with lace weight yarns and crochet threads. They are sized differently than regular hooks: the higher the number, the smaller the hook, which is the reverse of regular hook sizing. The smallest steel hook is a #14 or .9 mm; the largest is a 00 or 2.7 mm.

Knitting Abbreviations Master List

Following is a list of knitting abbreviations used by yarn industry designers and publishers. The most commonly used abbreviations are highlighted. In addition, designers and publishers may use special abbreviations in a pattern, which you might not find on this list. Generally, a definition of special abbreviations is given at the beginning of a book or pattern.

Abbreviation	Description
[]	work instructions within brackets as many times as directed
()	work instructions within parentheses in the place directed
* *	repeat instructions following the asterisks as directed
*	repeat instructions following the single asterisk as directed
"	inch(es)
alt	alternate
approx	approximately
beg	begin/beginning
bet	between
BO	bind off
CA	color A
CB	color B
CC	contrasting color
cm	centimeter(s)
cn	cable needle
CO	cast on
cont	continue
dec	decrease/decreases/decreasing
dpn	double pointed needle(s)
fl	front loop(s)
foll	follow/follows/following
g	gram
inc	increase/increases/increasing
k or **K**	knit
k2tog	knit 2 stitches together
kwise	knitwise
LH	left hand
lp(s)	loop(s)
m	meter(s)
M1	make one—an increase—several increases can be described as "M1"
M1 p-st	make one purl stitch
MC	main color
mm	millimeter(s)
oz	ounce(s)
p or **P**	purl

Abbreviation	Description
pat(s) or **patt**	pattern(s)
pm	place marker
pop	popcorn
p2tog	purl 2 stitches together
prev	previous
psso	pass slipped stitch over
pwise	purlwise
rem	remain/remaining
rep	repeat(s)
rev St st	reverse stockinette stitch
RH	right hand
rnd(s)	round(s)
RS	right side
sk	skip
skp	slip, knit, pass stitch over—one stitch decreased
sk2p	slip 1, knit 2 together, pass slip stitch over the knit 2 together; 2 stitches have been decreased
sl	slip
sl1k	slip 1 knitwise
sl1p	slip 1 purlwise
sl st	slip stitch(es)
ss	slip stitch (Canadian)
ssk	slip, slip, knit these 2 stiches together—a decrease
sssk	slip, slip, slip, knit 3 stitches together
st(s)	stitch(es)
St st	stockinette stitch/stocking stitch
tbl	through back loop
tog	together
WS	wrong side
wyib	with yarn in back
wyif	with yarn in front
yd(s)	yard(s)
yfwd	yarn forward
yo	yarn over
yrn	yarn around needle
yon	yarn over needle

Standard Yarn Weight System

Categories of yarn, gauge ranges, and recommended needle and hook sizes

Yarn Weight Symbol & Category Names	**0** Lace	**1** Super Fine	**2** Fine	**3** Light	**4** Medium	**5** Bulky	**6** Super Bulky
Type of Yarns in Category	Fingering 10 count crochet thread	Sock, Fingering, Baby	Sport, Baby	DK, Light Worsted	Worsted, Afghan, Aran	Chunky, Craft, Rug	Bulky, Roving
Knit Gauge Range* in Stockinette Stitch to 4 inches	33–40** sts	27–32 sts	23–26 sts	21–24 sts	16–20 sts	12–15 sts	6–11 sts
Recommended Needle in Metric Size Range	1.5–2.25 mm	2.25–3.25 mm	3.25–3.75 mm	3.75–4.5 mm	4.5–5.5 mm	5.5–8 mm	8 mm and larger
Recommended Needle U.S. Size Range	000 to 1	1 to 3	3 to 5	5 to 7	7 to 9	9 to 11	11 and larger
Crochet Gauge* Ranges in Single Crochet to 4 inch	32-42 double crochets**	21–32 sts	16–20 sts	12–17 sts	11–14 sts	8–11 sts	5–9 sts
Recommended Hook in Metric Size Range	Steel*** 1.6–1.4mm Regular hook 2.25 mm	2.25–3.5 mm	3.5–4.5 mm	4.5–5.5 mm	5.5–6.5 mm	6.5–9 mm	9 mm and larger
Recommended Hook U.S. Size Range	Steel*** 6, 7, 8 Regular hook B-1	B–1 to E–4	E–4 to 7	7 to I–9	I–9 to K–10½	K–10½ to M–13	M–13 and larger

* GUIDELINES ONLY: The above reflect the most commonly used gauges and needle or hook sizes for specific yarn categories.

** Lace weight yarns are usually knitted or crocheted on larger needles and hooks to create lacy, openwork patterns. Accordingly, a gauge range is difficult to determine. Always follow the gauge stated in your pattern.

*** Steel crochet hooks are sized differently from regular hooks--the higher the number, the smaller the hook, which is the reverse of regular hook sizing.

This Standards & Guidelines booklet and downloadable symbol artwork are available at: **YarnStandards.com**

Crochet Abbreviations Master List

Following is a list of crochet abbreviations used in patterns by yarn industry designers and publishers. The most commonly used abbreviations are highlighted. In addition, designers and publishers may use special abbreviations in a pattern, which you might not find on this list. Generally, a definition of special abbreviations is given at the beginning of a book or pattern.

Abbreviation Description

[] work instructions within brackets as many times as directed
() work instructions within parentheses as many times as directed
***** repeat the instructions following the single asterisk as directed
*** *** repeat instructions between asterisks as many times as directed or repeat from a given set of instructions
" inch(es)
alt alternate
approx . . approximately
beg begin/beginning
bet between
BL back loop(s)
bo bobble
BP back post
BPdc back post double crochet
BPsc back post single crochet
BPtr back post treble crochet
CA color A
CB color B
CC contrasting color
ch chain stitch
ch- refers to chain or space previously made: e.g., ch-1 space
ch-sp chain space
CL cluster
cm centimeter(s)
cont continue
dc double crochet
dc2tog . . . double crochet 2 stitches together
dec decrease/decreases/decreasing
dtr double treble
FL front loop(s)
foll follow/follows/following
FP front post

Abbreviation Description

FPdc front post double crochet
FPsc front post single crochet
FPtr front post treble crochet
g gram
hdc half double crochet
inc increase/increases/increasing
lp(s) loops
m meter(s)
MC main color
mm millimeter(s)
oz ounce(s)
p picot
pat(s)
 or patt . . pattern(s)
pc popcorn
pm place marker
prev previous
rem remain/remaining
rep repeat(s)
rnd(s) round(s)
RS right side
sc single crochet
sc2tog . . . single crochet 2 stitches together
sk skip
Sl st slip sitich
sp(s) space(s)
st(s) stitch(es)
tch
 or t-ch turning chain
tbl through back loop
tog together
tr treble crochet
trtr triple treble crochet
WS wrong side
yd(s) yard(s)
yo yarn over
yoh yarn over hook

Yarn label information

 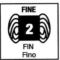

LACE	SUPER FINE	FINE	LIGHT	MEDIUM	BULKY	SUPER BULKY
0	**1**	**2**	**3**	**4**	**5**	**6**
DENTELLE Liston	SUPER FIN Super Fino	FIN Fino	LEGER Ligero	MOYEN Medio	BULKY Abultado	SUPER BULKY Super Abultado

Symbols

Symbols are used to designate the various weights (thicknesses) of yarn on labels and the skill level (beginner to experienced) of a pattern.

For yarn weights a ball/skein will be used containing a number between 0–6, with 0 the finest and 6 the thickest.

The skill level symbol is a horizontal bar divided into four sections. When one section of the bar is shaded, it indicates a beginner pattern; four shaded sections indicate a pattern for experienced knitters or crocheters.

Below is how you can expect to see the yarn symbols used on a label; and how the yarn and skill level symbols might appear in a pattern. See charts on pages 3 and 8 for more information about

what the new symbols will represent. (To download symbol artwork, go to: www.YarnStandards.com) As noted in the introduction, these changes will be implemented over time with the printing of new labeling and the publishing of new books, patterns and magazines.

MEDIUM **4** MOYEN MEDIO	10 x 10 cm 4x4 INCHES 5 mm 8 US 15 S 22 R	10 x 10 cm 4x4 INCHES 5.5 mm I-9 14 S 16 R	104°F 40°C	○

WORSTED • **MEDIUM** **4** MOYEN • MEDIO

Standard Body Measurements/Sizing

Most crochet and knitting pattern instructions will provide general sizing information, such as the chest or bust measurements of a completed garment. Many patterns also include detailed schematics or line drawings. These drawings show specific garment measurements (bust/chest, neckline, back, waist, sleeve length, etc.) in all the different pattern sizes. To insure proper fit, always review all of the sizing information provided in a pattern before you begin.

Following are several sizing charts. These charts show Chest, Center Back Neck-to-Cuff, Back Waist Length, Cross Back, and Sleeve Length **actual body measurements** for babies, children, women, and men. These measurements are given in both inches and centimeters.

When sizing sweaters, the fit is based on actual chest/bust measurements, plus ease (additional inches or centimeters). The first chart entitled "Fit" recommends the amount of ease to add to body measurements if you prefer a close-fitting garment, an oversized garment, or something in-between.

The next charts provide average lengths for children's, women's and men's garments.

Both the Fit and Length charts are simply guidelines. For individual body differences, changes can be made in body and sleeve lengths when appropriate.

However, consideration must be given to the project pattern. Certain sizing changes may alter the appearance of a garment.

HOW TO MEASURE

1. Chest/Bust
Measure around the fullest part of the chest/bust. Do not draw the tape too tightly.

2. Center Back Neck–to–Cuff
With arm slightly bent, measure from back base of neck across shoulder around bend of elbow to wrist.

3. Back Waist Length
Measure from the most prominent bone at base of neck to the natural waistline.

4. Cross Back
Measure from shoulder to shoulder.

5. Sleeve Length
With arm slightly bent, measure from armpit to cuff.

Child's (cont.)	12	14	16
1. Chest (in.)	30	31½	32½
(cm.)	76	80	82.5
2. Center Back	26	27	28
Neck-to-Cuff	66	68.5	71
3. Back Waist	15	15½	16
Length	38	39.5	40.5
4. Cross Back	12	12¼	13
(Shoulder to	30.5	31	33
Shoulder)			
5. Sleeve Length	15	16	16½
to Underarm	38	40.5	42

Woman's size	X-Small	Small	Medium	Large
1. Bust (in.)	28–30	32–34	36–38	40–42
(cm.)	71–76	81–86	91.5–96.5	101.5–106.5
2. Center Back	27–27½	28–28½	29–29½	30–30½
Neck-to-Cuff	68.5–70	71–72.5	73.5–75	76–77.5
3. Back Waist	16½	17	17¼	17½
Length	42	43	43.5	44.5
4. Cross Back	14–14½	14½–15	16–16½	17–17½
(Shoulder to	35.5–37	37–38	40.5–42	43–44.5
Shoulder)				
5. Sleeve Length	16½	17	17	17½
to Underarm	42	43	43	44.5

Woman's (cont.)	1X	2X	3X	4X	5X
1. Bust (in.)	44–46	48–50	52–54	56–58	60–62
(cm.)	111.5–117	122–127	132–137	142–147	152–158
2. Center Back	31–31½	31½–32	32½–33	32½–33	33–33½
Neck-to-Cuff	78.5–80	80–81.5	82.5–84	82.5–84	84–85
3. Back Waist	17¾	18	18	18½	18½
Length	45	45.5	45.5	47	47
4. Cross Back	17½	18	18	18½	18½
(Shoulder to	44.5	45.5	45.5	47	47
Shoulder)					
5. Sleeve Length	17½	18	18	18½	18½
to Underarm	44.5	45.5	45.5	47	47

FIT

Very-close fitting: Actual chest/bust measurement or less
Close-fitting: 1–2"/2.5–5cm
Standard-fitting: 2–4"/5–10cm
Loose-fitting: 4–6"/10–15cm
Oversized: 6"/15cm or more

LENGTH FOR CHILDREN

Waist length: Actual body measurement
Hip length: 2"/5cm down from waist
Tunic length: 6"/15cm down from waist

LENGTH FOR WOMEN

Waist length: Actual body measurement

Hip length: 6"/15cm down from waist

Tunic length: 11"/28cm down from waist

LENGTH FOR MEN

Men's length usually varies only 1–2"/ 2.5–5cm from the actual "back hip length" measurement (*see chart*)

Baby's size	3 months	6 months	12 months	18 months	24 months
1. Chest (in.)	16	17	18	19	20
(cm.)	40.5	43	45.5	48	50.5
2. Center Back Neck-to-Cuff	10½	11½	12½	14	18
	26.5	29	31.5	35.5	45.5
3. Back Waist Length	6	7	7½	8	8½
	15.5	17.5	19	20.5	21.5
4. Cross Back (Shoulder to shoulder)	7¼	7¾	8¼	8½	8¾
	18.5	19.5	21	21.5	22
5. Sleeve Length to Underarm	6	6½	7½	8	8½
	15.5	16.5	19	20.5	21.5

Child's size	2	4	6	8	10
1. Chest (in.)	21	23	25	26½	28
(cm.)	53	58.5	63.5	67	71
2. Center Back Neck-to-Cuff	18	19½	20½	22	24
	45.5	49.5	52	56	61
3. Back Waist Length	8½	9½	10½	12½	14
	21.5	24	26.5	31.5	35.5
4. Cross Back (Shoulder to shoulder)	9¼	9¾	10¼	10¾	11¼
	23.5	25	26	27	28.5
5. Sleeve Length to Underarm	8½	10½	11½	12½	13½
	21.5	26.5	29	31.5	34.5

Man's Size	Small	Medium	Large	X-Large	XX-Large
1. Chest (in.)	34–36	38–40	42–44	46–48	50–52
(cm.)	86–91.5	96.5–101.5	106.5–111.5	116.5–122	127–132
2. Center Back Neck-to-Cuff	32–32½	33–33½	34–34½	35–35½	36–36½
	81–82.5	83.5–85	86.5–87.5	89–90	91.5–92.5
3. Back Hip Length	25–25½	26½–26¾	27–27¼	27½–27¾	28–28½
	63.5–64.5	67.5–68	68.5–69	69.5–70.5	71–72.5
4. Cross Back (Shoulder to Shoulder)	15½–16	16½–17	17½–18	18–18½	18½–19
	39.5–40.5	42–43	44.5–45.5	45.5–47	47–48
5. Sleeve Length to Underarm	18	18½	19½	20	20½
	45.5	47	49.5	50.5	52

Head Circumference Chart

	Infant/Child				Adult	
	Premie	Baby	Toddler	Child	Woman	Man
6. Circumference						
(in.)	12	14	16	18	20	22
(cm.)	30.5	35.5	40.5	45.5	50.5	56

For an accurate head measure, place a tape measure across the forehead and measure around the full circumference of the head. Keep the tape snug for accurate results.

Web Sites for Knitters

Americasknitting.com helps you locate a knitting store near you at home or on vacation.

Angelhairyarn.com has a comprehensive list of knitting references in movies and television.

Cocoknits.com

Craftbits.com

Craftgossip.com

Craftstylish.com

Craftzine.com magazine

Crochetpatterncentral.com

Dailyknitter.com

Etsy.com

Knitbits at Berroco.com

Knitmap.com

Knitnet.com

Knittingdaily.com

KnittingtipsbyJudy.com

Learntoknit.com

Pantone.com is a great site to help you plan your knitting wardrobe colors and keep up with the trends in fashion.

Ravelry.com—Enjoy the online community, groups, patterns, designers and resources.

Texere.com—Learn how to tie your scarves.

Follow all your favorite knitting stores, designers, and fellow knitters on Twitter.com.

Books for Your Library

Every knitter needs a basic library with much-needed information to refer to periodically. I have listed some of my favorites here and on my Web site, *knit1fortheroad.com*. New books are added so stop by often.

101 Designer One-Skein Wonders, edited by Judith Durant

150 Crochet Trims, by Susan Smith

150 Knitted Trims, by Lesley Stanfield

200 Knitting Tips, Techniques & Trade Secrets, by Betty Barnden

Anticraft Knitting Beading and Stitching for the Slightly Sinister, by Renee Rigdon and Zabet Stewart

Knit Aid rx for Knitters, by Vickie Howell

Knitting Tips & Trade Secrets Expanded, from Taunton Press

Stitch 'n Bitch: The Knitter's Handbook, by Debbie Stoller

The Knitter's Guide to Combining Yarns: 300 Foolproof Pairings, by Kathleen Greco

Vogue Dictionary of Knitting Stitches, by Anne Matthews

Calendars

365 Knitting Stitches a Year: Perpetual Calendar, Martingale & Company

365 Crochet Stitches a Year: Perpetual Calendar, by Jean Leinhauser and Rita Weiss

First Knitting Graphic Novel

Handknit Heroes is a story about teens with superpowers, a single mom, and her yarn shop. Written by Stephanie Bryant and illustrated by Marc Olivent, each issue features a single knitting pattern for beginner to early intermediate knitters. You and your teen will enjoy a great read. Visit their Web site, comicknits.com.

The *Knit Princess* is another super fun graphic novel by writer and self-proclaimed obsessed knitter Allison Sarnoff and the artist Melody Moore. The storyline follows a young girl and her knitting adventures. I love her message of improving your knitting skills, not to be afraid to try new techniques, and the humor, of course. The fact that the Knit Princess is wearing a tiara definitely is a plus for me. Who wouldn't want to wear a tiara while you're knitting? We should all feel like a princess—or prince—when we knit. Visit knitprincess.com for details.

Podcasts

Here a few podcasts that I enjoy and hope you will, too. Many of your favorite online yarn stores now have podcasts to inspire, instruct, and update you on the latest knitting news, events, and trends.

yarncraft.lionbrand.com

knitpicks.com

gettingloopy.com

CRL at vickiehowell.com

The knitting resources, books, and links have been compiled from my Web site, *knit1fortheroad.com*, which is constantly updated with new links and resources for the busy knitter.

Final Thoughts

I hope you have found this knitting pattern book inspirational and filled with hours of knitting fun. My wish for you is that you continue along your knitting journey and discover the Knitavian side of your creativity. I'll see you at the crossroads of Inspiration Avenue and Knitavia Blvd. soon.
Margaret

Notes and Ideas

About Margaret Nock

Margaret Nock is a business woman, knitter, blogger and author of Knit 1 for the Road, a portable knitting book for busy knitters. She has a MS from Savannah College of Art and Design and has written articles for Mix Tape craft magazine. Margaret enjoys blogging about knitting events, products, and interviewing indie crafters, writers, knitting charities and businesses. Margaret is a member of The Knitting Guild Association, The Crochet Guild of America, and Knitters Connection.

Margaret says that color and texture really inspire her and she tries to use eco-friendly materials as much as possible.

When she isn't spending time with family and friends, you will find Margaret, with her knitting projects, on the road sharing her love of knitting and community.

Margaret lives in Maryland with her two Yorkies, Molly and Max, and husband, Dave.

LaVergne, TN USA
12 September 2010
196733LV00002B